POSTCARD HISTORY SERIES

Solvang

Curt Cragg

ARCADIA
PUBLISHING

Published by Arcadia Publishing
Charleston, South Carolina

Printed in the United States of America

Library of Congress Catalog Card Number: 2008921578

For all general information contact Arcadia Publishing at:
Telephone 843-853-2070
Fax 843-853-0044
E-mail sales@arcadiapublishing.com
For customer service and orders:
Toll-Free 1-888-313-2665

Visit us on the Internet at www.arcadiapublishing.com

CONTENTS

Acknowledgments 6

Introduction 7

1. The Pioneer Town 9

2. School and Church 17

3. Buellton's Famous Dane 33

4. Main Street 45

5. Danish Architecture 51

6. Windmills 59

7. Motels and Shops 65

8. Danish Days 73

9. Alisal Guest Ranch 83

10. The Santa Ynez Valley 89

ACKNOWLEDGMENTS

Collecting postcards begins as a hobby but ends up being an addiction that is hard to overcome. Perhaps there are some things in life one doesn't need to get over. The author acknowledges and thanks the following individuals, institutions, and postcard publishers for their contributions to this book: postcard collectors John Fritsche, Joy Chamberlain, Alan Fox, and David Cole for exposing me to this hobby-turned-addiction; the Santa Ynez Valley Historical Society, the Elverhoj Museum of History and Art, and the Buellton Historical Society; Mark and Linda Parsons, whose dad, Leonard, was responsible for many of the images on these real photo postcards and sold many of them from his Rexall drugstore on Main Street in Solvang before, and soon after, Solvang became a modern tourist destination; and publishers Bob Ball, Nielen, Goodwin, Colourpicture, Actual Photo Company, the Albertype Company and the many photographers that trudged from town to town with camera in hand to take all of these photographs.

All images in this book are from the author's collection.

INTRODUCTION

Solvang was never intended to be a tourist destination. In fact, becoming a tourist town was far more accidental than intentional. Some of the early locals may have recognized the potential benefit from outside commerce, but there was not necessarily a well-organized effort to pursue it.

In its early genesis, Solvang was established for cultural, educational, and religious purposes. It was established in California because many of the Danes that had already migrated from their native home in Denmark to the midwestern United States were simply tired of the cold winters. California offered sunshine and promise, which is why they chose the Danish name *Solvang*, interpreted in English as "sunny fields."

Despite the promise of good weather, settlers did not flock in droves to California at first. A few hardy pioneers made the commitment and packed up their homes and families to head west. The first groups to arrive gave mixed initial reviews about life in California. They discovered that indeed it was sunny and, in fact, it was downright hot in the summer. They also discovered that California's cycle of drought could be hard on crops that depended on at least some measure of regular rainfall.

Many of the early arrivals depended on dry farming to both feed their dairy cows and make a living selling hay. The year Solvang was founded was rather wet, but it was followed by several dry years just as the new settlers were arriving. As a result, the first seasons of crops did not come in well for lack of rain. However, as always happens in California, the rain finally fell, and then it would hardly stop, producing some bumper crops in the years ahead.

As the population grew, the infrastructure of a pioneer town soon took shape. This included the construction of a Danish college. Word of good crops and a growing Danish colony in California soon brought more of the reluctant midwesterners out to the new community. The town center of Solvang slowly began to grow as well. Yet, from a distance, Solvang resembled any other pioneer western town, with typical shops and clapboard-sided buildings. There really wasn't much to suggest that the town was any different than any of the surrounding towns of Los Olivos, Santa Ynez, Ballard, or Buellton—at least not until one overheard a conversation between two Danes and couldn't begin to decipher what was being said between them in their native tongue.

This idyllic lifestyle would continue in pretty much the same manner until after World War II. However, with the stroke of a pen and a few pictures, everything seemingly changed overnight. Most modern historians would probably point to this one instance of postwar publicity as the foundation that would alter the face of Solvang forever. It didn't actually

change Solvang instantly, but the seeds were sown such that thousands of outsiders would soon discover this latent tourist attraction and keep coming back.

The watershed event that put Solvang on the map was an article published in the January 18, 1947, edition of the *Saturday Evening Post*. It was titled "Little Denmark," and author Dean Jennings's observations about the town were well illustrated with a series of large color photographs. For some reason, this article captured the attention of Southern Californians as a promising destination. Tourists began flocking to the Danish town just a few hours north of the Los Angeles basin. It was a perfect Sunday drive away for a culture fascinated with their automobiles.

The Danes capitalized on the attention by developing an annual celebration called Danish Days, which soon attracted thousands of visitors. An adoption of Danish provincial architecture soon caught on, as shops converted to the look of Denmark, and the little town began to change.

These changes are apparent today, but it requires a look back in time through the lens of these postcard photographers to appreciate how Solvang began as a little Danish colony in the Santa Ynez Valley.

One

THE PIONEER TOWN

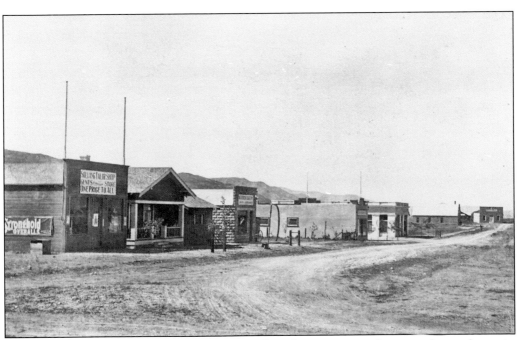

MAIN STREET, SOLVANG, C. 1914. Dirt roads and western storefronts made up the main street of Solvang's early business district. There was nothing distinctly Danish about the town when it was first established in 1911.

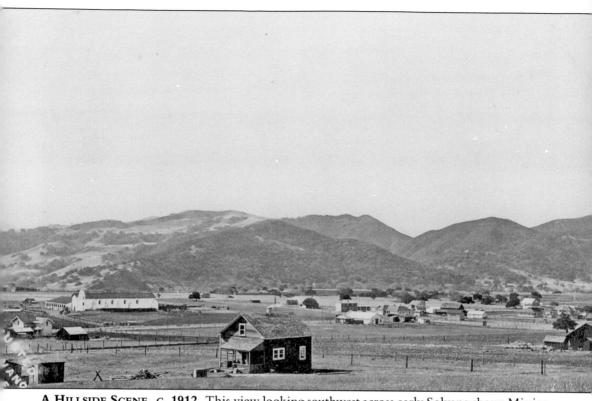

A HILLSIDE SCENE, C. 1912. This view looking southwest across early Solvang shows Mission Santa Ines in the middle left. The two-story structure to the right in the middle of the picture was the original home of the Solvang Folk School until Atterdag College was completed.

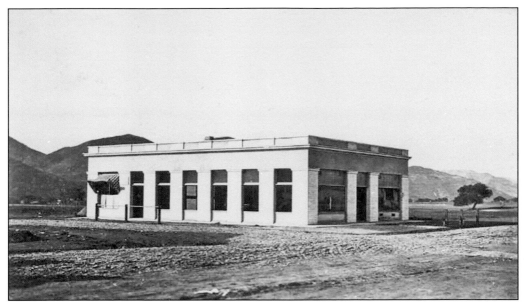

SANTA YNEZ VALLEY BANK, SOLVANG, C. 1914. The most substantial building in the new town was the bank, built of block. The solid construction provided a sense of security in contrast to some of the other buildings, which looked like they might be blown down in strong winds.

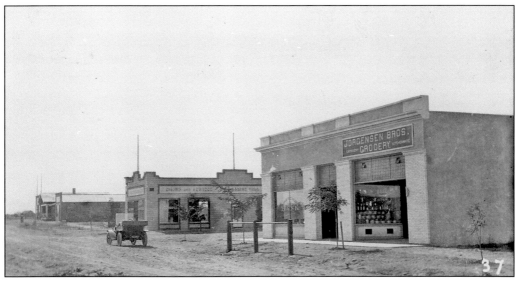

JORGENSEN BROTHERS GROCERY, C. 1914. The Jorgensen brothers opened a grocery and general merchandise store next door to the bank. Down the street, Andrew Andersen opened a pool hall and cigar shop—necessary diversions in a pioneer town. The hitching post in front of the bank indicates the main mode of transportation at the time was via horseback, although one of the few horseless carriages in town can also be seen in this photo postcard.

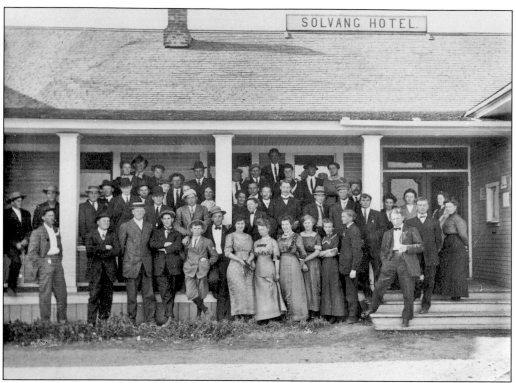

SOLVANG HOTEL, C. 1916. The Solvang Hotel was one of the earliest structures built in town and housed the first families that arrived as they awaited the construction of their new homes. As this group attests, it was also a popular gathering place for social events.

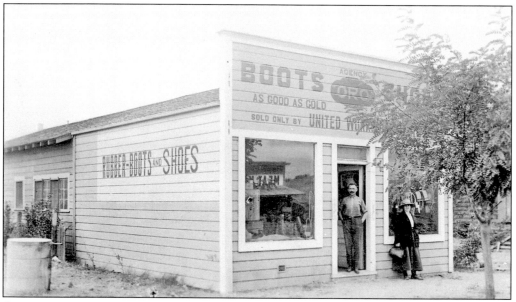

ANDERSEN'S SHOE STORE, C. 1918. Ludwig Andersen was the town cobbler, crafting shoes for the hardworking Danes in the community. Like many of the early businesspeople, his living quarters were attached to the back of the shop, as seen in this picture postcard.

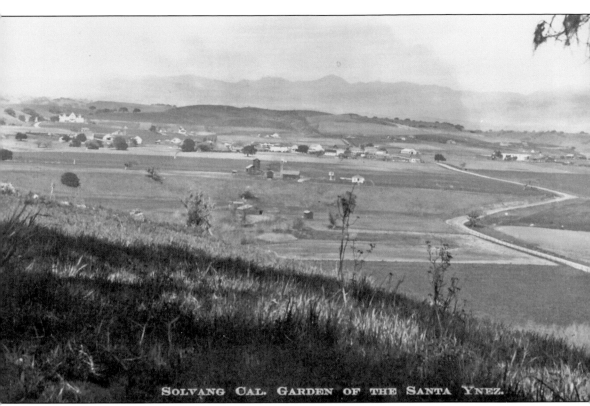

SOLVANG CAL. GARDEN OF THE SANTA YNEZ.

ON A HILL FAR AWAY, C. 1916. This panoramic view shows Atterdag College on a hillside above the town to the left. The large structure to the right is Mission Santa Ines, and in the middle sits "Solvang, The Garden of Santa Ynez," as proclaimed by this postcard.

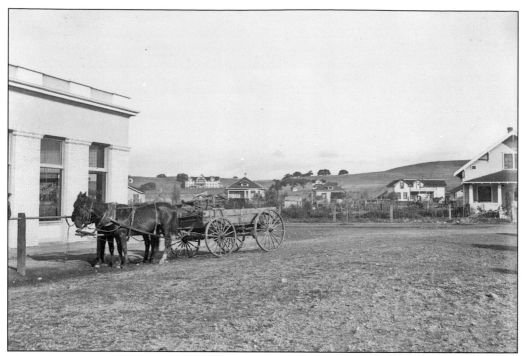

RIDE-THROUGH BANKING, C. 1914. This drive-up window at the Santa Ynez Valley Bank was designed to accommodate horse and wagon. In the background, some of the early Craftsman-style residences line Mission Drive. Catalog homes were shipped to Gaviota Wharf and hauled to Solvang to be constructed, as very little lumber was available locally.

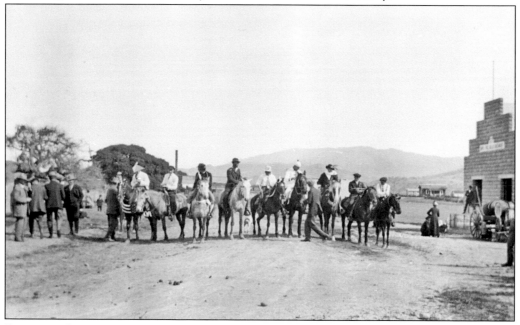

SOLVANG CREAMERY, C. 1916. A group of costumed characters lines up for a horse race, probably in observation of a local holiday. To the right is the Solvang Creamery, where much of the milk from the surrounding dairy farms was processed.

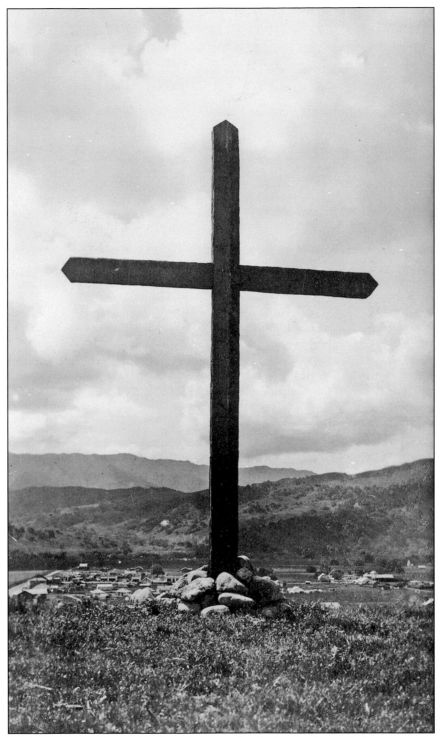

THE EASTER CROSS. On a hill near the top of today's Alisal Road, the Easter Cross was the starting point for sunrise services, followed by an annual walk to the old mission on Easter Sunday.

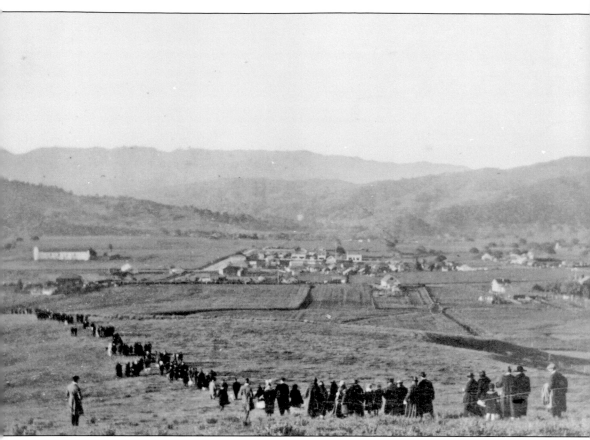

THE EASTER WALK. Practicing Catholics and the Lutheran Danes join together for the annual Easter sojourn from the Easter Cross to Mission Santa Ines. Although the Danes founded Solvang to establish a Danish Lutheran church, they had no objection to maintaining an ecumenical relationship with their Catholic neighbors.

Two

SCHOOL AND CHURCH

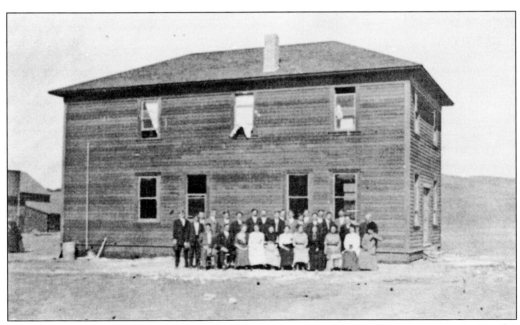

THE SOLVANG FOLK SCHOOL. The school was one of the first buildings constructed in the town of Solvang. It opened in November 1911. Forty-one students attended the first year, including some boarders and several of the newly arrived local residents.

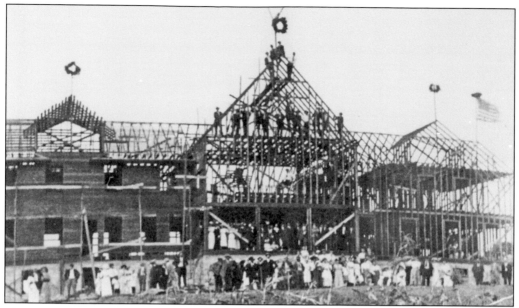

THE ATTERDAG COLLEGE REJSEGILDE, 1914. One of the first objectives of the founders of Solvang was to establish a school patterned after Grandview College in Des Moines, Iowa. A Danish celebration called *rejsegilde* was held on August 25, 1914, to commemorate raising the highest rafters of the building.

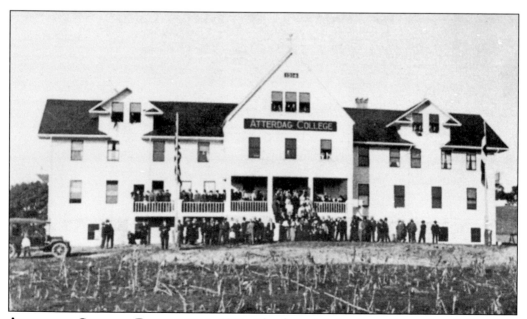

ATTERDAG COLLEGE DEDICATION, 1914. The formal dedication of Atterdag College was celebrated over two days on December 13 and 14, 1914. The locals turned out in force to celebrate this historic event.

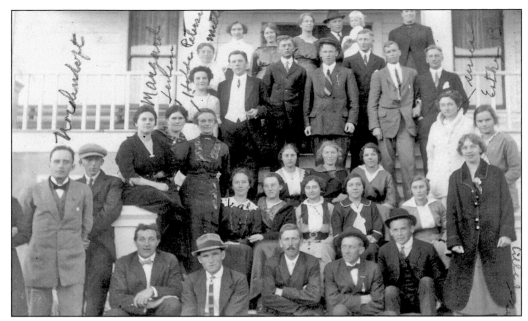

THE FIRST CLASSES HELD, 1915. The first classes were held at Atterdag soon after it opened. This postcard labeled by one of the students was sent to friends or family in Santa Barbara. Rev. Benedict Nordentoft, on the far left, was one of the original founders of Solvang.

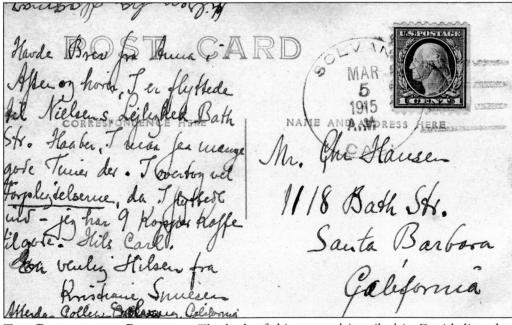

THE BACK OF THE POSTCARD. The back of this postcard inscribed in Danish lists class members and friends with a salutation to relatives in Santa Barbara.

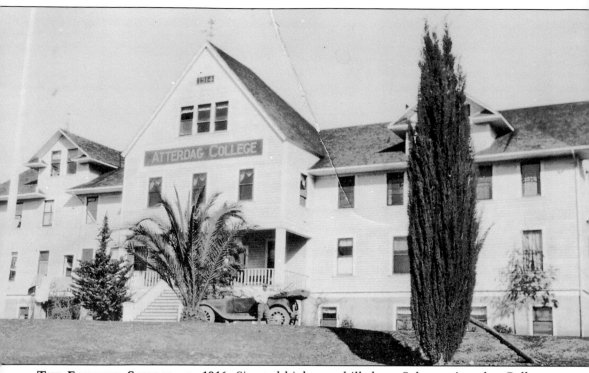

THE FINISHED SCHOOL, C. 1916. Situated high on a hill above Solvang, Atterdag College was a prominent feature for years. College classes ended in 1937, but the school was still used as a Danish folk school until 1951.

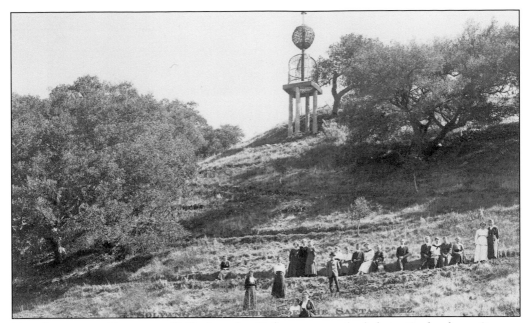

THE ATTERDAG BOWL, C. 1918. Atterdag College was perched above Fredensborg Canyon to the west. This canyon created a natural bowl for an outdoor theater. Seats and a stage area were carved into the hillside for performances of Danish dramas performed by the students and local actors.

THE ATTERDAG BOWL, C. 1918. A wider shot of the Atterdag Bowl area shows a horse-and-buggy posed on what is known today as Fredensborg Canyon Road. Other students line the hillside to pose for this postcard photograph.

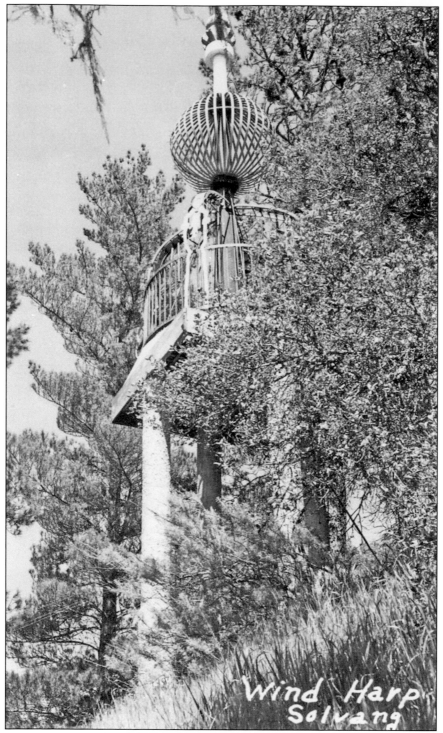

THE AEOLIAN HARP. The aeolian harp still exists today, although partially obscured by large oak trees. It was designed to catch the wind blowing from the west and up the canyon, creating music from its reverberations.

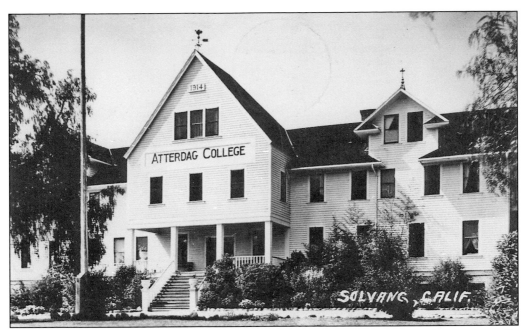

ATTERDAG COLLEGE AGES WELL, *C.* **1945.** Despite the diminishing interest in an all-Danish education, Atterdag College continued to offer classes and be used as a civic center for special events.

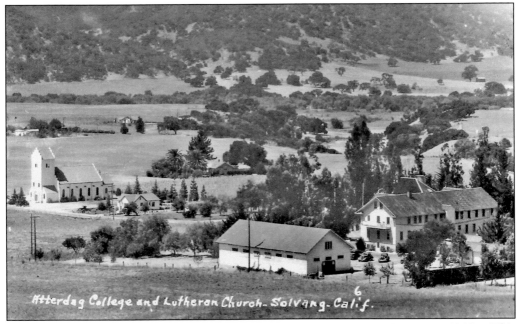

ATTERDAG COLLEGE LOOKING TOWARD BETHANIA LUTHERAN CHURCH, 1940S. This photograph taken from behind Atterdag College shows the open spaces surrounding Solvang before World War II. After the war, a building boom and increased tourism would change Solvang forever and eventually lead to the end of Atterdag.

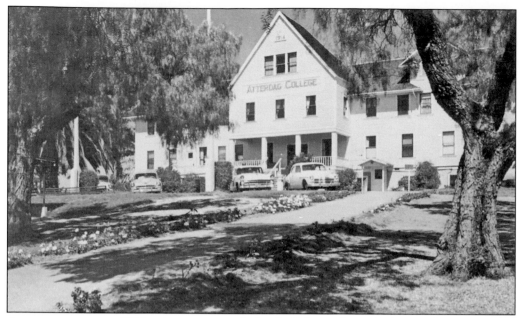

ATTERDAG IN THE 1950S. An aging population in Solvang demanded space for retirees, and the idea was conceived to construct a retirement community on the college property. Land was donated in front of the college building in July 1950, with the first residences completed in 1953.

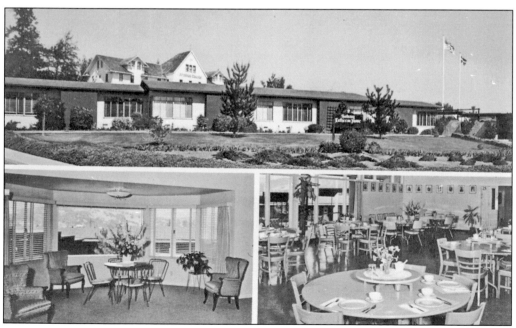

ATTERDAG AND THE SOLVANG LUTHERAN HOME. The Solvang Lutheran Home was constructed in front of Atterdag College at the end of Atterdag Road. By the 1970s, demand for more senior housing dictated the demolition of the old college building to make way for more rooms. Sadly this historic building was torn down and is now remembered in picture postcard photographs.

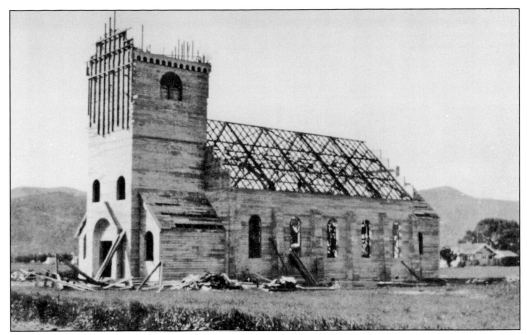

BETHANIA LUTHERAN CHURCH, 1927. The founders of Solvang had two primary objectives when they established their Danish colony: build a college and build a church. The college was built in 1914, but it took until 1927 to get the church construction underway. In the meantime, church services were held at Atterdag College.

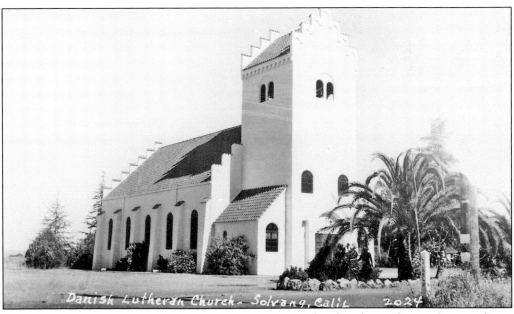

BETHANIA LUTHERAN CHURCH COMPLETED, 1928. The church was designed to emulate a similar sanctuary in Denmark. It cost $15,000 to construct and was dedicated on July 8, 1928.

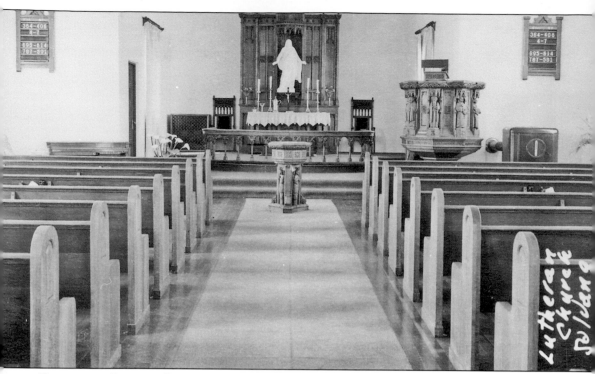

BETHANIA CHURCH INTERIOR, 1940s. The beautifully designed interior of the church and the ornately carved front doors and interior woodwork are a testament to the Danish craftsmanship that went into its construction.

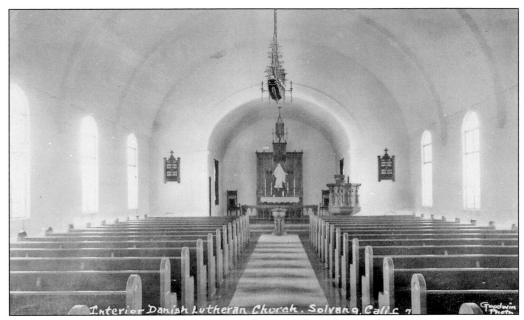

BETHANIA LUTHERAN CHURCH, 1940s. To complete the details on the interior of the church, wood carver Jes Smidt of Luck, Wisconsin, spent four years hand carving the altar rail, chairs, pulpit, and baptismal font. The Christ statue is a copy of an original created by Bertel Thorvaldsen for the Church of Our Lady in Copenhagen, Denmark.

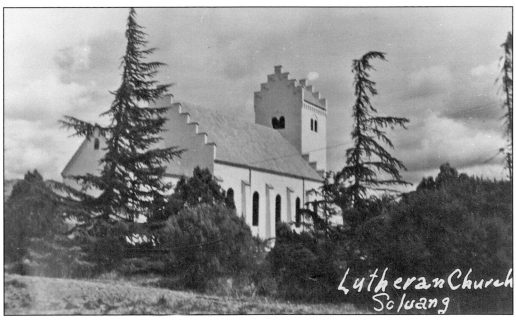

BETHANIA CHURCH, 1950s. The bell in the church tower was salvaged from a trash pile by Rasmus Jensen. Originally intended to be a warning bell during World War II, it now rings for peace over Solvang.

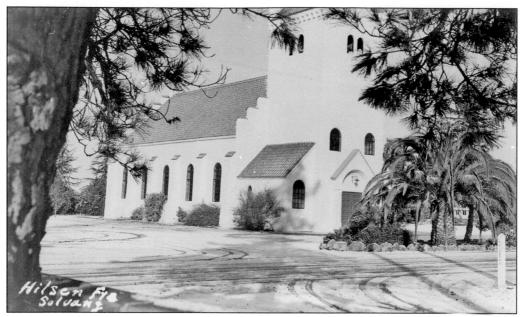

BETHANIA CHURCH. This postcard image clearly shows the palm tree planted in front of the church. Palms were also planted in front of the homes of the arriving Danes as a symbol of life in California. Even today, there is never a lack of palm fronds in Solvang for Palm Sunday celebrations.

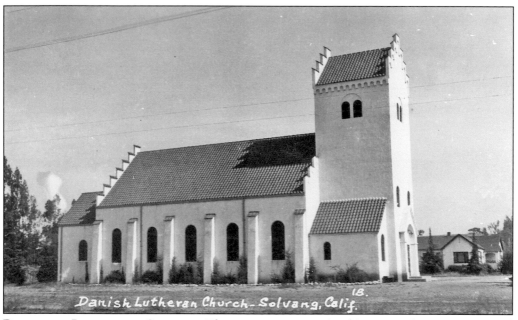

BETHANIA LUTHERAN CHURCH. The parsonage seen in this postcard was constructed in 1952 to provide a residence for the serving pastors. The small home is still used today as church offices.

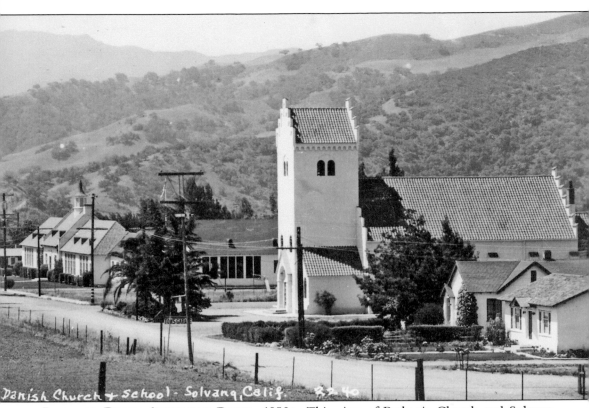

Danish Church + school - Solvang, Calif. 32 40

LOOKING DOWN ATTERDAG ROAD, 1950S. This view of Bethania Church and Solvang School was taken from below Atterdag College looking south. The church and the school were built on the outskirts of the town at the time, although today they have been enveloped by homes.

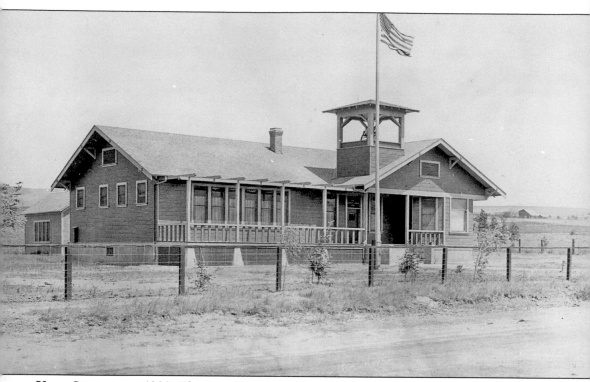

YNEZ SCHOOL, C. 1920. The Ynez School predated the town of Solvang. It was established in 1905 to provide schooling for children on the surrounding ranches. When the Danes established Solvang in 1911, it also served as the first home for the Danish Lutheran congregation.

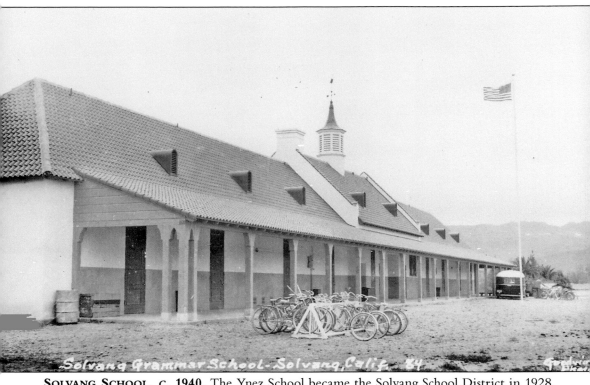

Solvang Grammar School - Solvang, Calif. 84

SOLVANG SCHOOL, C. 1940. The Ynez School became the Solvang School District in 1928. The original wood school building served students until this new school opened on Atterdag Road in January 1940.

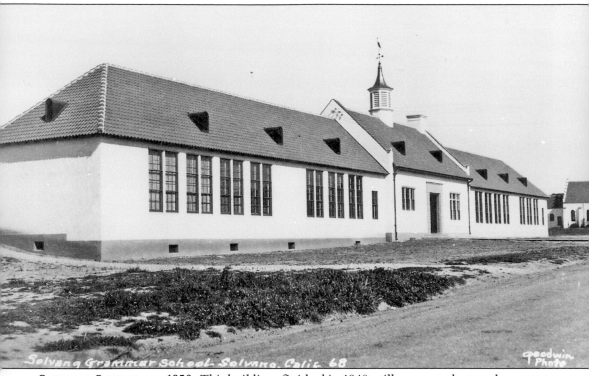

Solvang Grammar School, Solvang, Calif. 68

Goodwin Photo

SOLVANG SCHOOL, C. 1950. This building, finished in 1940, still serves students today as part of the Solvang School campus. Since 1940, several additions have been built surrounding the first classrooms, making up the modern school on this site.

Three

BUELLTON'S FAMOUS DANE

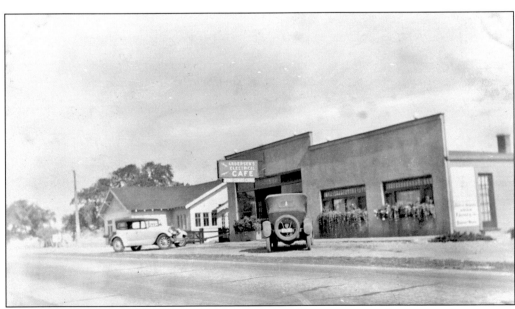

ANDERSEN'S ELECTRICAL CAFÉ, 1924. An enterprising Dane named Anton Andersen came to Solvang to visit his brother Andrew. He and his wife, Juliette, fell in love with the place and decided to open a small diner, but instead of opening in Solvang, he chose what he felt would be a more visible location fronting on the Coast Highway, which would later become Highway 101. The Andersens opened their café in Buellton on Friday, June 13, 1924.

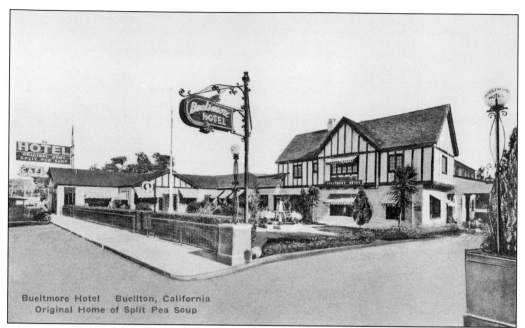

Bueltmore Hotel Buellton, California
Original Home of Split Pea Soup

ANDERSEN'S BUELTMORE HOTEL, 1928. The little diner was so successful that the Andersens decided to expand. They took in a partner and built a 16-room hotel that they named the Bueltmore in joking deference to Anton's days as a chef at the swankier Biltmore Hotel in Los Angeles. They also built a larger diner next to the hotel.

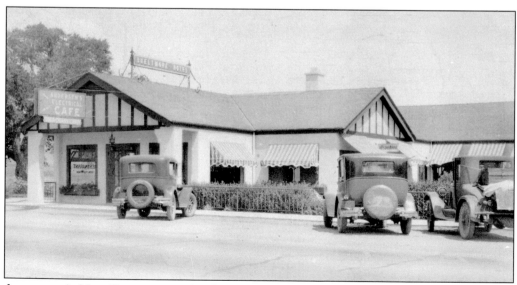

ANDERSEN'S NEW ELECTRICAL CAFÉ, 1928. The new restaurant and hotel were located on a lot next to the original diner. The Andersens kept the name and sign from the Electrical Café, so named because they were using modern all-electric appliances.

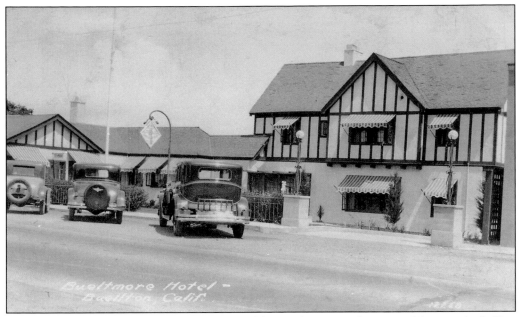

THE BUELTMORE HOTEL, C. 1930. The hotel featured some modern amenities, too, including telephones and steam-heated bathrooms in each room. A steady stream of highway traffic kept the diner and hotel busy.

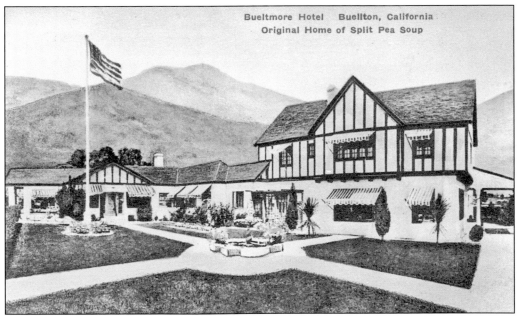

ALBERTYPE EMBELLISHMENTS, C. 1930. A designer from the Albertype Postcard Company embellished the mountains behind the Bueltmore in this artistically enhanced rendering, bringing them closer to Buellton than they appear in real life.

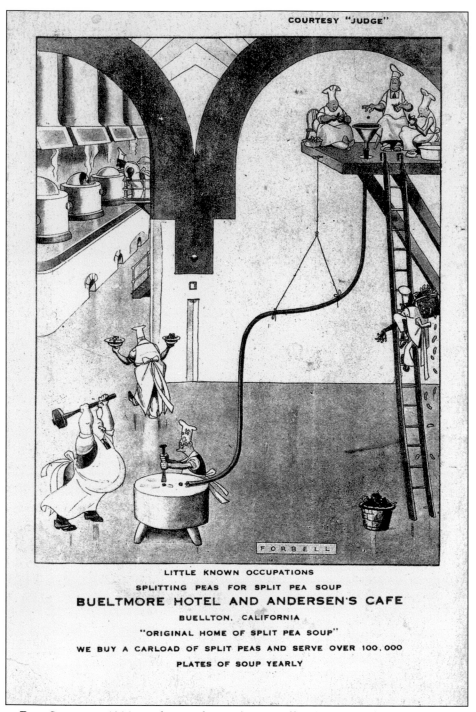

LITTLE KNOWN OCCUPATIONS

SPLITTING PEAS FOR SPLIT PEA SOUP

BUELTMORE HOTEL AND ANDERSEN'S CAFE

BUELLTON, CALIFORNIA

"ORIGINAL HOME OF SPLIT PEA SOUP"

WE BUY A CARLOAD OF SPLIT PEAS AND SERVE OVER 100,000

PLATES OF SOUP YEARLY

SPLIT PEA SOUP, C. 1931. Early on, the Andersens offered a recipe for split pea soup that Juliette had learned from her mother growing up in France. The delicious soup was an instant success and soon became the specialty of the house. Ironically, a cartoon published in a humor magazine in 1931 provided the perfect postcard icon for promoting the Andersens' famous dish.

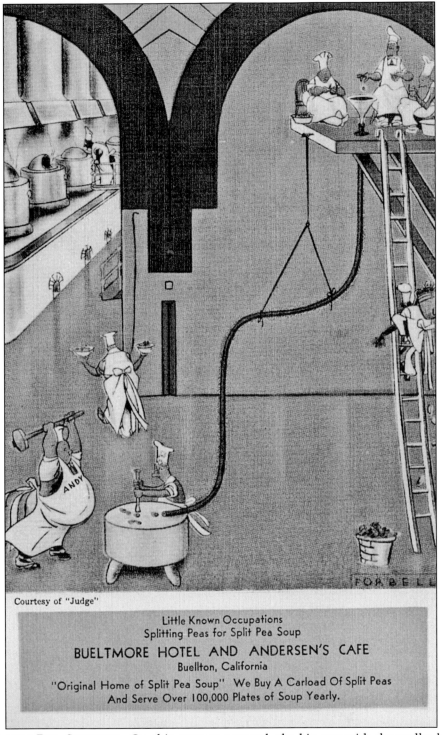

Little Known Occupations
Splitting Peas for Split Pea Soup

BUELTMORE HOTEL AND ANDERSEN'S CAFE
Buellton, California

"Original Home of Split Pea Soup" We Buy A Carload Of Split Peas
And Serve Over 100,000 Plates of Soup Yearly.

ANDY THE PEA SPLITTER. On this cartoon postcard, the big guy with the mallet has the name "Andy" on his apron. This was a nickname for Anton Andersen, the founder of the split pea enterprise.

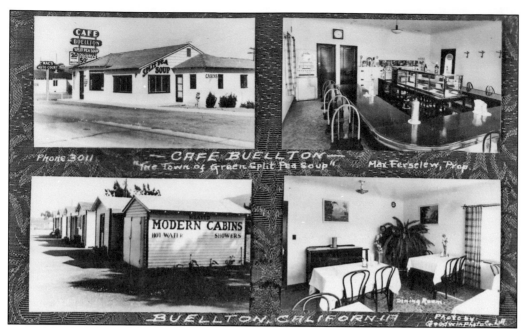

PEA SOUP IMPOSTER. In the 1930s, a neighboring café owner attempted to siphon off some of the success of the Andersen's split pea soup. The Andersens' cartoon characters and postcard enabled them to establish themselves as the "Original Home of Split Pea Soup."

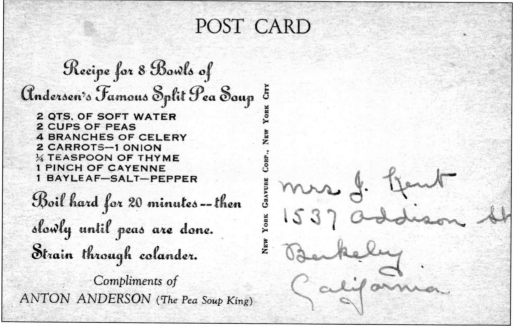

THE FAMOUS RECIPE. On the back of the cartoon postcard, the Andersen's published their pea soup recipe, which they freely shared with their customers. This saved them the time of having to write it out when customers asked.

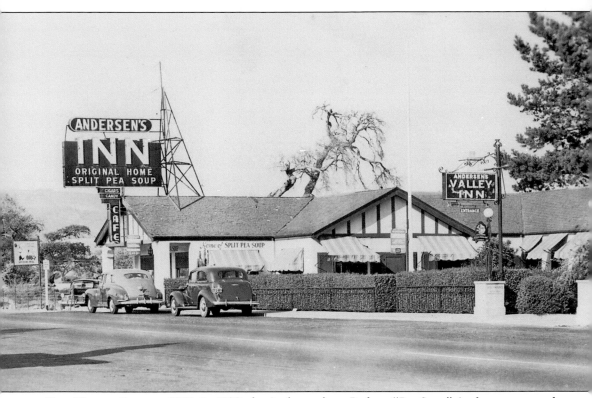

THE VALLEY INN, C. 1945. In 1938, the Andersens' son Robert "Pea Soup" Andersen assumed operation of the family business. One of his first orders of business was a name change from the Bueltmore Hotel to the Valley Inn, as seen in this postcard photograph.

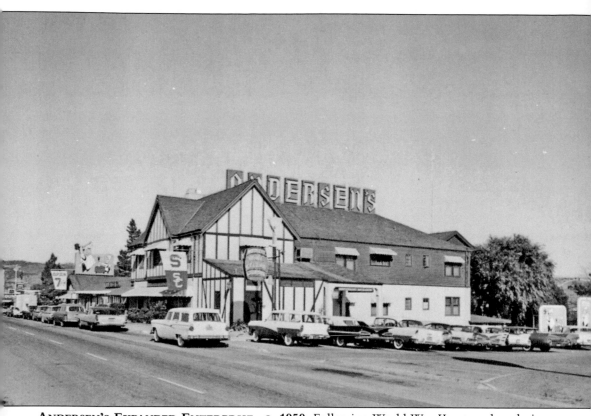

ANDERSEN'S EXPANDED ENTERPRISE, C. 1959. Following World War II, a travel explosion brought thousands to Andersen's and the nearby town of Solvang. The restaurant was significantly expanded under the directorship of Robert "Pea Soup" Andersen.

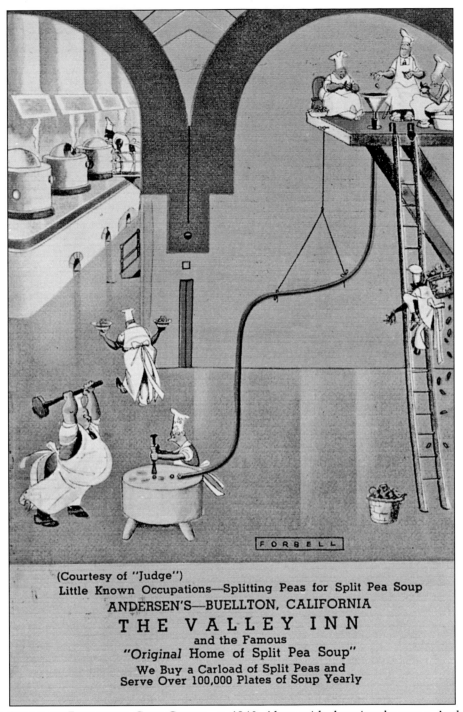

Little Known Occupations—Splitting Peas for Split Pea Soup

ANDERSEN'S—BUELLTON, CALIFORNIA

THE VALLEY INN

and the Famous

"Original Home of Split Pea Soup"

We Buy a Carload of Split Peas and
Serve Over 100,000 Plates of Soup Yearly

THE CARTOON POSTCARD GETS COLOR, C. 1940. Along with changing the name, Andersen also had an artist add color to the cartoon card. Thousands of these cards were circulated, making it one of the most prolific postcards ever created. If the customer filled out the card in the restaurant, the Andersens would pay for the postage and mail it for them from the Buellton post office.

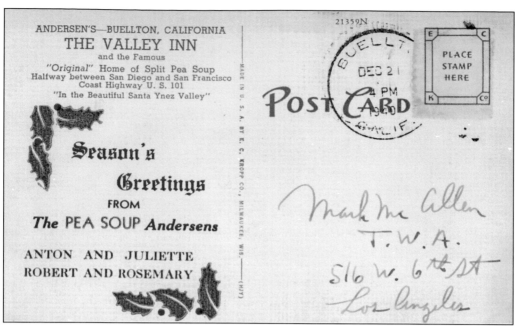

ANDERSEN'S—BUELLTON, CALIFORNIA
THE VALLEY INN
and the Famous
"*Original*" Home of Split Pea Soup
Halfway between San Diego and San Francisco
Coast Highway U. S. 101
"In the Beautiful Santa Ynez Valley"

Season's

Greetings

FROM

The PEA SOUP *Andersens*

ANTON AND JULIETTE
ROBERT AND ROSEMARY

MADE IN U. S. A. BY E. C. KROPP CO., MILWAUKEE, WIS.——(HJY)

21359N

POST CARD

BUELLT.
DEC 2 1
4 PM
1940
CALIF.

PLACE
STAMP
HERE

Mark Mc Allen
T. W. A.
516 W. 6th St
Los Angeles

It Even Doubles as a Christmas Card. In 1940, the Andersens used the back of the cartoon postcard as their Christmas greeting card. The cartoon was also used on billboards along Highway 101 north and south to lead people to the home of the original split pea soup in Buellton.

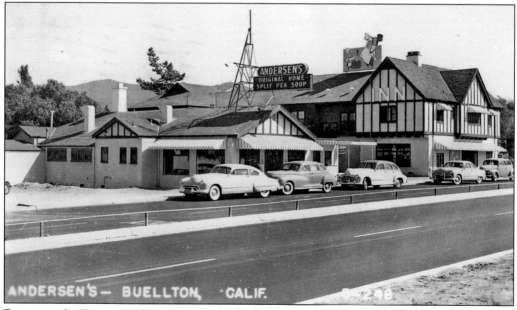

ANDERSEN'S — BUELLTON, CALIF.

Buellton's Extreme Makeover. In 1948, Buellton was reshuffled when Highway 101 was widened through the middle of town. Andersen's diner had to be moved back to make room for the new highway lanes. When the highway project was completed in 1949, Buellton was dubbed "Service Town, U.S.A.," with Andersen's as the flagship at the main intersection.

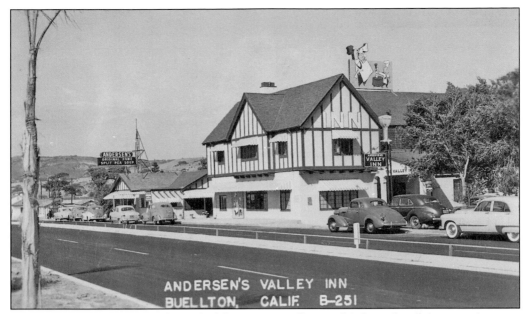

A TRAVEL EXPLOSION. At the end of the 1940s, Buellton and Solvang began to experience an explosion in tourism as car–crazy Californians took to the open road and discovered the Santa Ynez Valley. Widespread publicity for Solvang's Danish Days brought thousands of travelers streaming through Buellton and Andersen's now-famous restaurant.

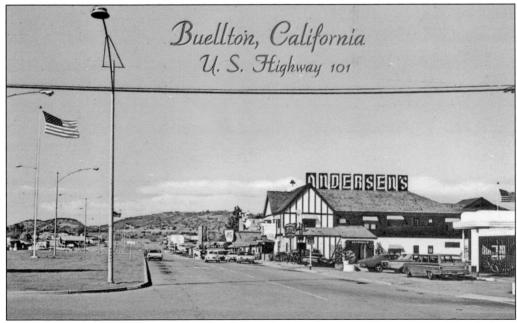

THE FREEWAY BYPASS, C. 1964. In the middle of the 1960s, a new freeway was constructed to the east of town, bypassing Buellton and Andersen's restaurant. The road that remained where the highway once ran was renamed Avenue of Flags, which is where Andersen's is located today.

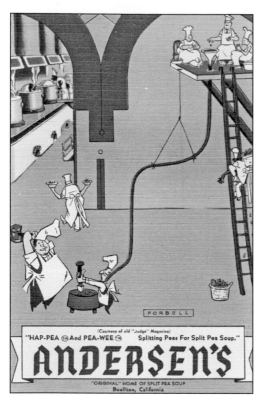

A CARTOON MAKEOVER. Following World War II, Robert Andersen unveiled updated cartoon characters on the pea soup postcard. Disney artist Milt Neil redrew the two main characters. In a contest, they were soon named Hap-Pea and Pea-Wee. This enduring icon of Andersen's is now recognized by millions of highway travelers.

ANDERSEN'S EXPANDED, C. 1979. The Andersens sold their flagship enterprise soon after the new freeway bypassed Buellton. New owner Vincent Evans expanded the business to three other locations, as this postcard advertises. Today only the Buellton and Santa Nella locations remain, but Andersen's may expand again soon.

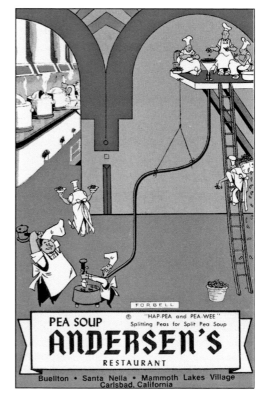

Four

MAIN STREET

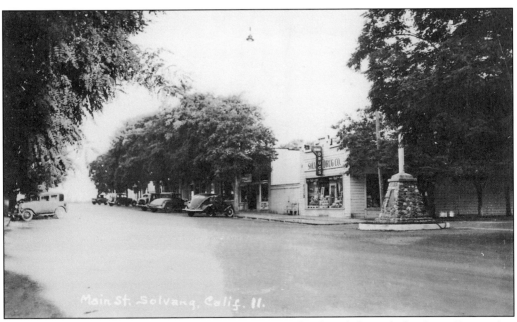

MAIN STREET U.S.A., SOLVANG, C. 1940. Solvang slumbered through the Great Depression of the 1930s with a minimal amount of growth. In the 1940s, Main Street in Solvang still looked pretty much like any other main street in a rural town. That wouldn't change until some time after World War II, when tourism dawned on the little Danish town.

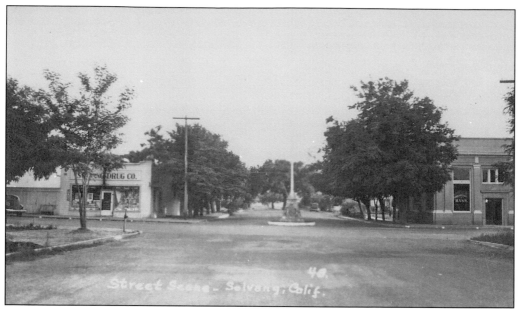

FIRST AND MAIN STREETS, C. 1940. The Solvang Drug Company, owned by the Parsons, anchored one corner of the intersection, and the Santa Ynez Valley Bank, built in 1914, retained its solid position across the street. The flagpole was erected in honor of the veterans of World War I.

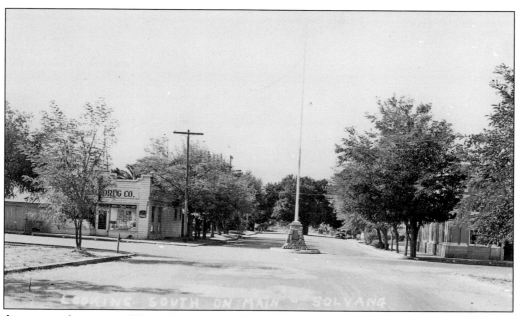

ANOTHER ANGLE ON MAIN STREET, C. 1940. Either the photographer over-imbibed, or he had trouble setting up his tripod straight. Of course, it may not have even been the photographer but the technician that printed it crooked. In any case, the town may be somewhat conservative, but it doesn't lean nearly this far to the right.

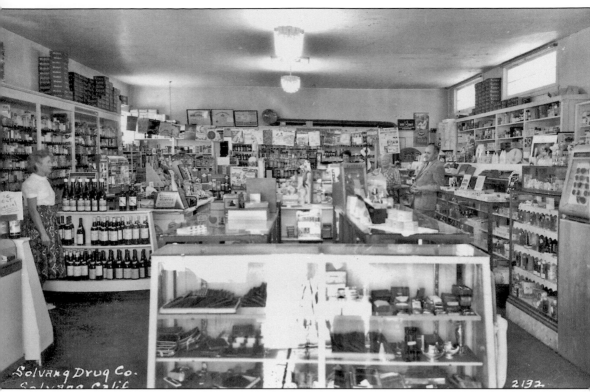

SOLVANG DRUG COMPANY, C. 1946. Interior photographs from the early period of Solvang are difficult to find printed on postcards. This rare exception shows the variety of merchandise offered at the Solvang Drug Company, owned by the Parsons family. Evidently wine was a popular local libation even in the 1940s.

EVERYDAY NECESSITIES ON MAIN STREET, 1950s. Like the main street in any other community, downtown Solvang offered the sundries necessary for everyday living, including a real estate office, shoe store, furniture store, electronics, and groceries. There was very little oriented toward the tourist or visitor.

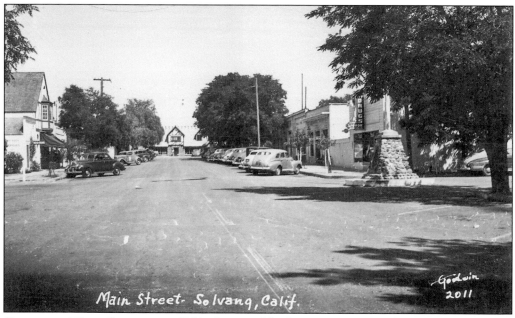

CHANGING MAIN STREET, C. 1950. One notable change occurred at the end of Main Street around 1948. It would portend the future of the little Danish community that would change from Main Street, U.S.A., to tourism central throughout the next decade. Even the name Main Street would ultimately be changed to Copenhagen Drive in recognition of this shift in trade.

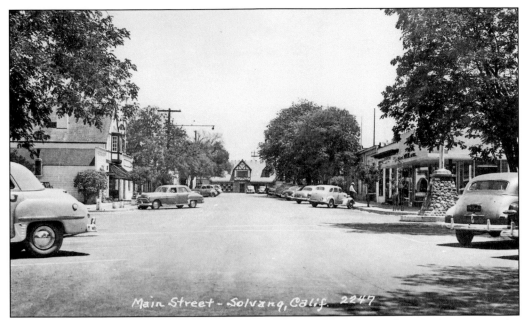

DANISH STYLE INTRODUCED, C. 1948. The change at the end of Main Street was the construction of the first commercial building in town to exhibit Danish-style architecture. Raymond Paaske designed a building to reflect details seen on buildings in Copenhagen, Denmark, setting a new tone for the downtown area.

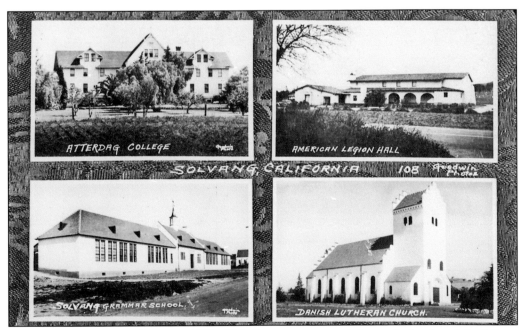

FOUR POSTCARDS IN ONE, C. 1940. This four-way postcard shows the landmark buildings of Solvang prior to World War II. The Danish Lutheran church was modeled after a church in Denmark, but the other buildings were more American than Danish. As tourism became the trade following the war, the trend in architecture would change significantly.

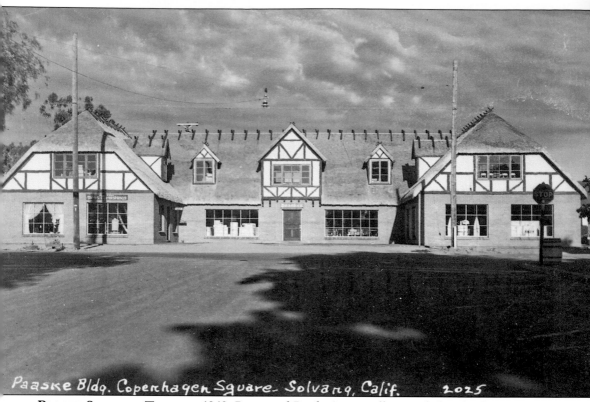

Paaske Bldg. Copenhagen Square Solvang, Calif. 2025

PAASKE SETS THE TONE, C. 1949. Raymond Paaske is generally regarded as the first Dane to set the tone for Danish-style architecture in Solvang. He even named his building Copenhagen Square. Although modest in comparison to some of Solvang's current trends toward Danish architecture, this building set the tone that many would soon follow, and the shift ultimately changed Main Street into Copenhagen Drive.

Five

DANISH ARCHITECTURE

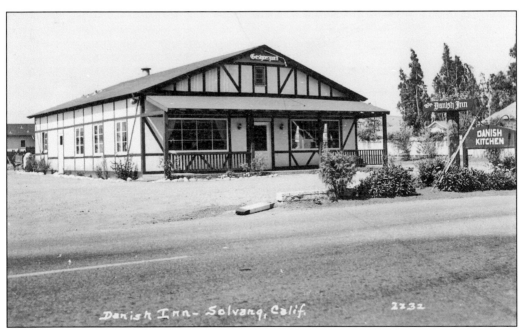

THE DANISH INN, C. 1950. Paaske set a trend that others soon followed. Bits of Danish architecture began appearing throughout town as tourism increased, spurred on by an article in a 1947 edition of the *Saturday Evening Post*. The locals began to see the potential of promoting a Danish town.

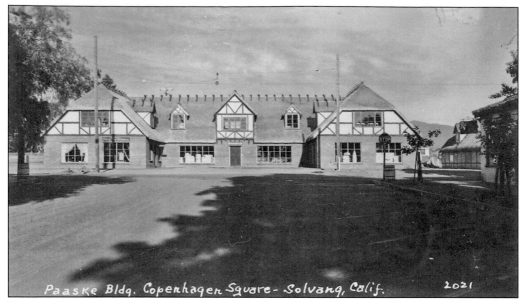

Paaske Bldg. Copenhagen Square- Solvang, Calif. 2021

PAASKE SELLS FURNITURE, C. 1949. Even though the style was Danish, Paaske opened a furniture store in his building and catered to the local trade. The industry of selling trinkets to tourists hadn't emerged yet, as Solvang was still mostly selling home goods.

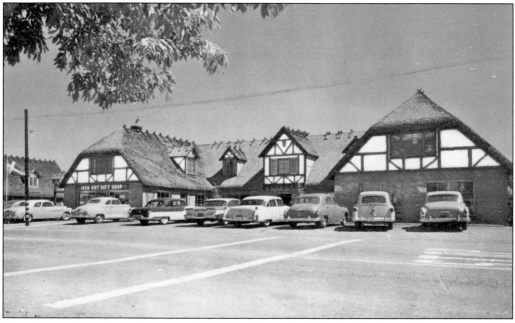

THE IRON ART GIFT SHOP, C. 1959. By the end of the 1950s, it was becoming evident there was money to be made by catering to the tourist trade that appeared in Solvang on the weekends. Most of the traffic came from day-trippers out of the Los Angeles basin looking for a leisurely weekend drive. One end of Paaske's building became a gift shop, another new trend that continues unabated in Solvang.

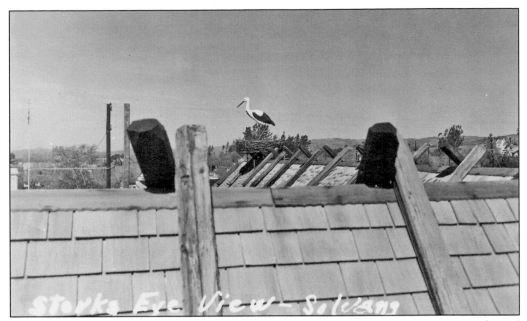

CROSS-HATCHING AND STORK NESTS, 1950s. In Solvang, a stork nest is a sign of good luck placed at the peaks of roofs as architectural accents. The cross-hatching is to keep away bad luck, or more specifically to keep evil spirits from landing on the roof. Both are traditions borne of Danish folklore.

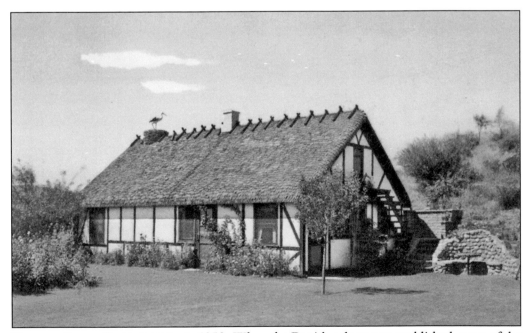

DANISH-STYLE RESIDENCES, C. 1950. When the Danish colony was established, most of the homes were California Craftsman in style. It wasn't until later that the trend in Danish-style architecture carried over to residential construction.

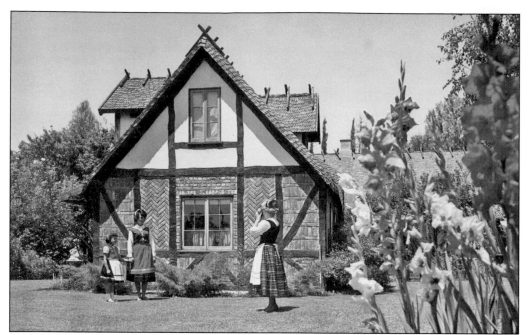

A Picture-Perfect Postcard, c. 1950. Although there are some examples of Danish styling in residential construction, the vast majority of homes tend toward more conventional construction. However, the commercial district has unanimously embraced the look of Northern Europe by instituting design guidelines for the tourist commercial area.

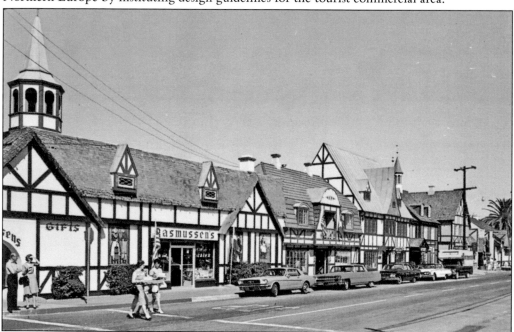

A View along Alisal, c. 1960. This view along the west side of Alisal Road confirms the prevalence of the Danish design trend being embraced in the commercial district of Solvang. This trend, which started soon after World War II, has continued to influence the face of Solvang even today.

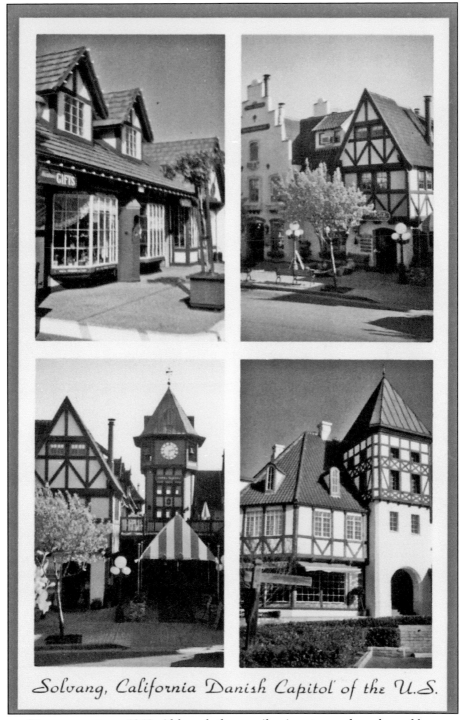

Solvang, California Danish Capitol of the U.S.

DANISH DISNEYLAND, C. 1960. Although the moniker is not warmly embraced by everyone, locals often jokingly refer to modern Solvang as "Danish Disneyland." Given the proliferation of twinkle lights and faux Danish facades, this tongue-in-cheek reference may not be far off the mark.

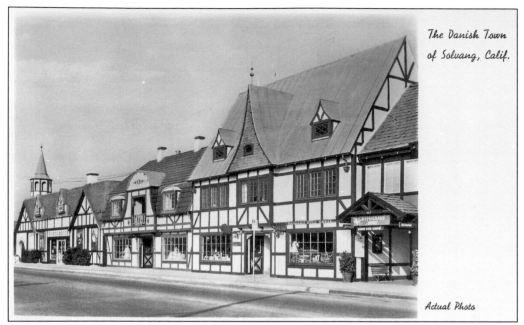

The Danish Town of Solvang, Calif.

Actual Photo

THE DANISH TOWN CALLED SOLVANG, C. 1960. All humor aside, there is no doubt Solvang holds a special charm that draws people to this small town. Perhaps it is the aroma of pastries or the pleasure of a town center where people still walk rather than drive.

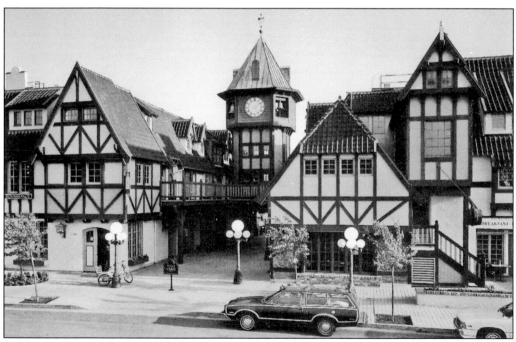

CLOCK TOWERS AND STREETLIGHTS, C. 1960. When people take the time to walk, there is so much to observe in Solvang. Architectural details like clock towers, spiral spires, weather vanes, and stork nests embellish buildings all along Copenhagen Drive, Mission Drive, and Alisal Road.

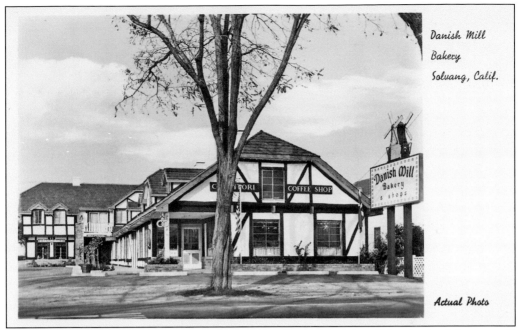

Danish Mill
Bakery
Solvang, Calif.

Actual Photo

DANISH PASTRY—THE REAL THING, C. 1950. One thing that did exist in Solvang well before it became a tourist destination, and still is prevalent today, is the real Danish pastry. These are not to be confused with the continental breakfast version that some call "Danish"— these are the buttery, mouth-watering, and warm fresh-baked goods.

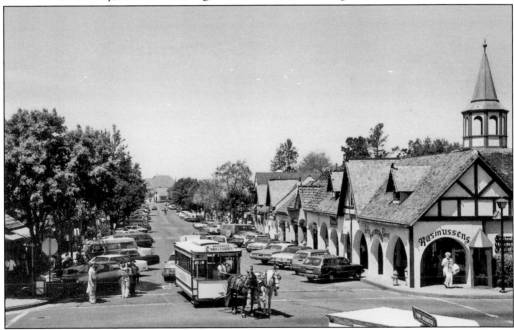

THE HONEN, C. 1960. The horse-drawn trolley, designed after a similar vehicle in Copenhagen, Denmark, still travels the streets of Solvang today, giving visitors a unique perspective on the modern Danish town. The beautiful Belgian draft horses that pull the Honen are a favorite sight for visitors and locals.

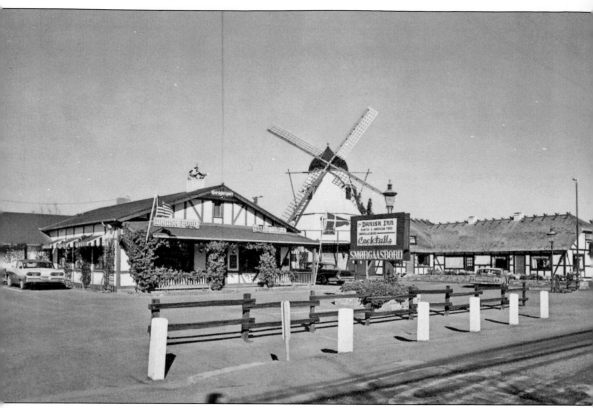

THE WINDMILLS, c. 1950. There is one architectural detail that is prevalent throughout Solvang and merits its own chapter. Celebrated by photographers and proliferating on postcards, it appears as though there is a windmill on every corner of the Danish village—and if the truth be told, it is probably true.

Six

WINDMILLS

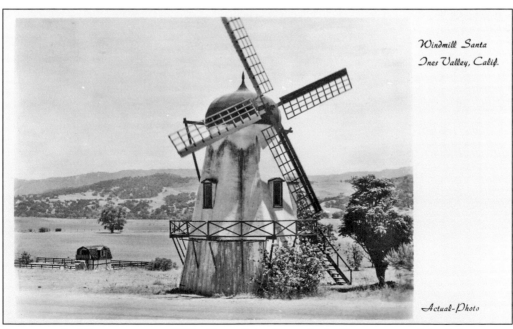

Windmill Santa
Ines Valley, Calif.

Actual-Photo

SORENSEN'S WINDMILL, C. 1950. One of the first windmills constructed in Solvang was never intended to be a tourist attraction, although it has been the subject of numerous postcard photographs. What makes it compelling for photographers is the scenic background of the Santa Ynez Mountains and the open fields that were once part of the vast Mission Santa Ines property.

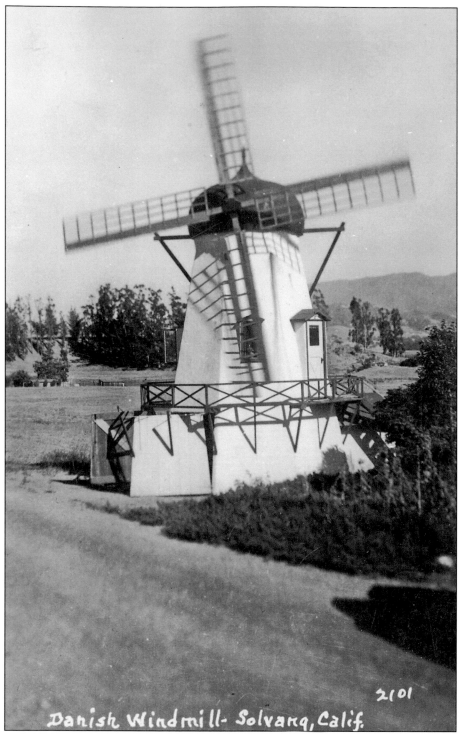

2101

Danish Windmill- Solvang, Calif.

SORENSEN'S WINDMILL, C. 1948. Ferdinand Sorensen's windmill is perhaps the most accurate representation of a Danish provincial style. It was built in 1947 on private property, where it still stands today.

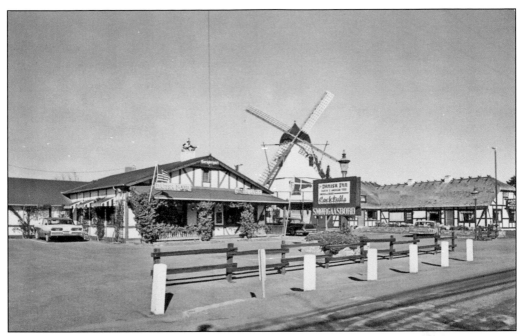

THE DANISH INN, C. 1960. The Danish Inn was built in 1950 by Borge and Mimi Andresen. The Andresens came to Solvang directly from Denmark. Their Danish Inn contributed to the growing trend in Danish provincial architecture that was started by Raymond Paaske. They took it a step further by adding a windmill.

THE DANISH INN WINDMILL, C. 1960. The Andresens added the windmill to their Danish Inn in 1957 as the interest and popularity of Solvang as a tourist destination was growing by leaps and bounds. The annual Danish Days festival was attracting thousands of visitors to Solvang.

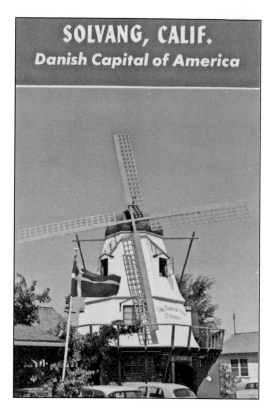

SOLVANG, CALIF.
Danish Capital of America

THE DANISH CAPITAL OF AMERICA. Who knows when Solvang officially became the "Danish Capital of America"? It was certainly more Danish in language and culture prior to World War II, but after the war, Danish architecture permeated the town, including the now well-known windmills.

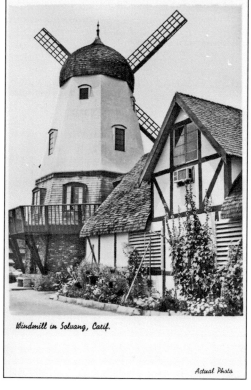

Windmill in Solvang, Calif.

Actual Photo

THE OLD MILL LOFT. The windmills in Solvang are not just decorative. They have all featured a variety of businesses throughout their lives. From restaurants to gift shops, the windmills are open to the public and worth a visit.

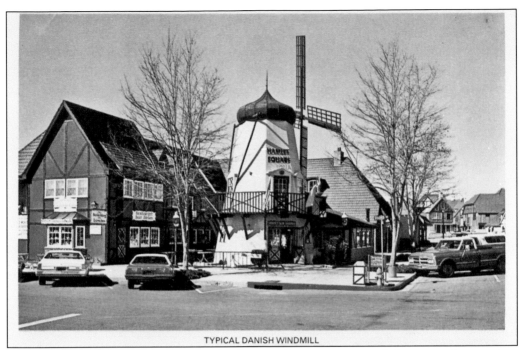

TYPICAL DANISH WINDMILL

HAMLET SQUARE WINDMILL. Windmills in Solvang create confusion sometimes, when people mix Denmark with Holland, which is a country perhaps more predominantly known for its windmills. Whether influenced by the Dutch or the Danes, most of the windmills in Solvang are just Americanized interpretations designed primarily to decorate the town.

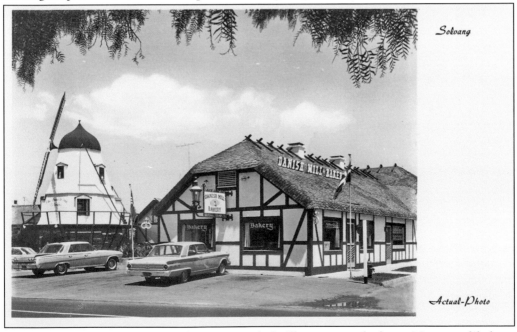

Solvang

Actual-Photo

DANISH MILL BAKERY. In any direction a windmill can cast a shadow, visitors are likely to find a Danish bakery. Actually, in today's Solvang, they are just as likely to find a wine-tasting room. What goes best with pastry, red or white wine?

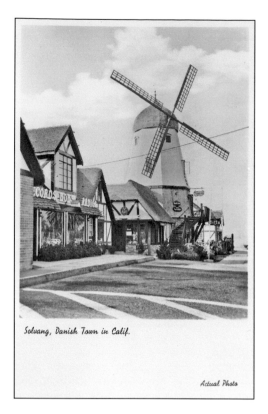

Solvang, Danish Town in Calif.

Actual Photo

A View along Alisal, c. 1960. When Solvang was established, the view along Alisal Road was pure country. Today that view has changed to Danish provincial, with a strong leaning toward tourism. Looking closely at this postcard, one will see that at least one of the shops in Solvang once sold records and hi-fi equipment.

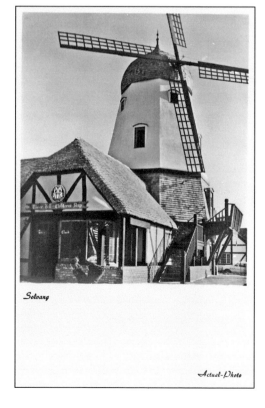

Solvang

Actual-Photo

A New Wind in the Air. Although the windmills remain today as a reminder of the Danish heritage of Solvang, there is a notable change in the wind. Where trinket shops once filled spaces, wine-tasting rooms are rapidly replacing bakeries, T-shirt shops, and blue Delft plates. The popularity and proliferation of Santa Barbara County wines has had a notable influence on Solvang.

64

Seven

Motels and Shops

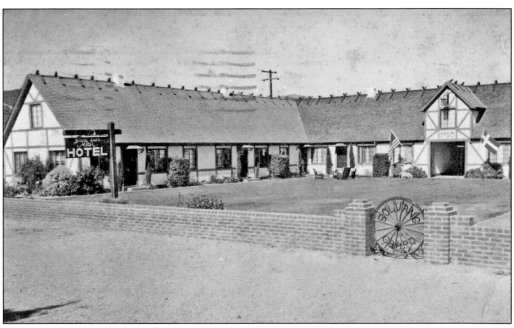

Solvang's First Motel. The Solvang Hotel, built in 1911, was actually the first hotel in Solvang, but it was converted to other uses before tourism struck. The Solvang Gaard was the first motel of the post–World War II era devoted to tourism. It actually began as an apartment building and was converted to guest rooms in 1953. Like bakeries and windmills, motels would begin to proliferate in Solvang.

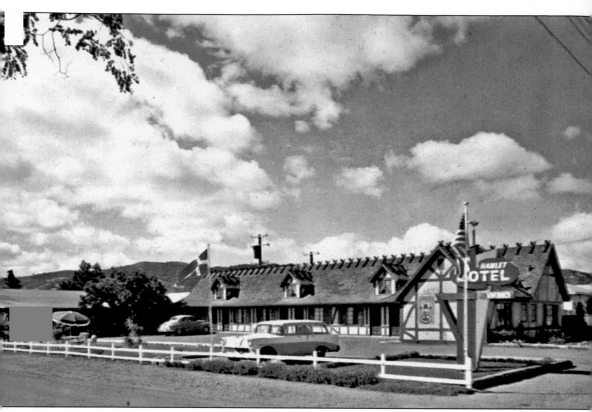

THE HAMLET MOTEL, C. 1950. By the time the Hamlet Motel was built, Danish provincial architecture was in full swing in Solvang, as this postcard attests. Listed features on the back of the card promoted its proximity to "restaurants, pancake house and Danish shops."

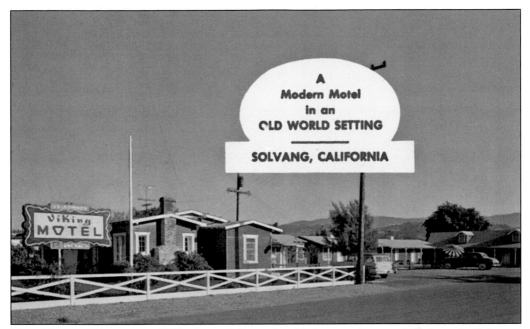

THE VIKING MOTEL, C. 1950. One of the early additions to the motel business in Solvang, the Viking Motel provided rooms for out–of–town visitors. It was one of several early motels that would soon contribute to a vibrant tourism industry in Solvang.

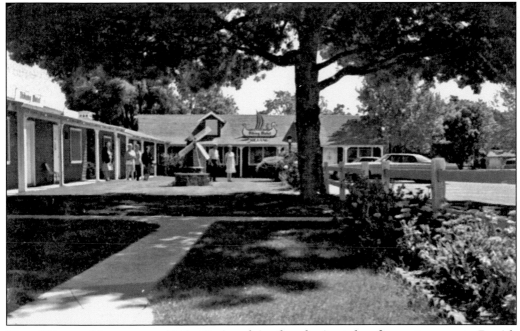

THE VIKING MOTEL, C. 1960. Designed in the classic style of a motor court, Danish decorations including a Viking ship and miniature windmill adorned this quaint inn. This motel remains nearly unchanged today.

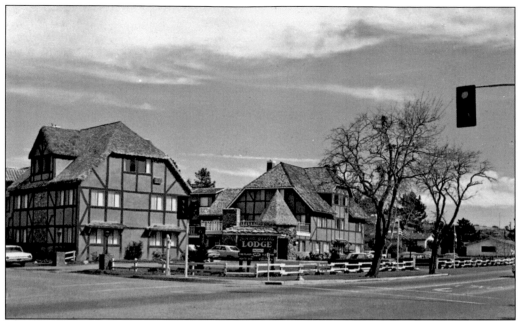

SVENSGAARD'S LODGE. Constructed in the late 1960s, this motel represented a trend toward buildings that were more hotel-sized. Increasing interest in Danish Days and other local events provided more demand for overnight and weekend visits to Solvang.

THE SOLVANG GAARD REVISITED. Solvang's first official motel was this small inn that is still serving customers today. The recently renovated rooms include antique furnishings and beautiful decorations, making this a must-see in Solvang.

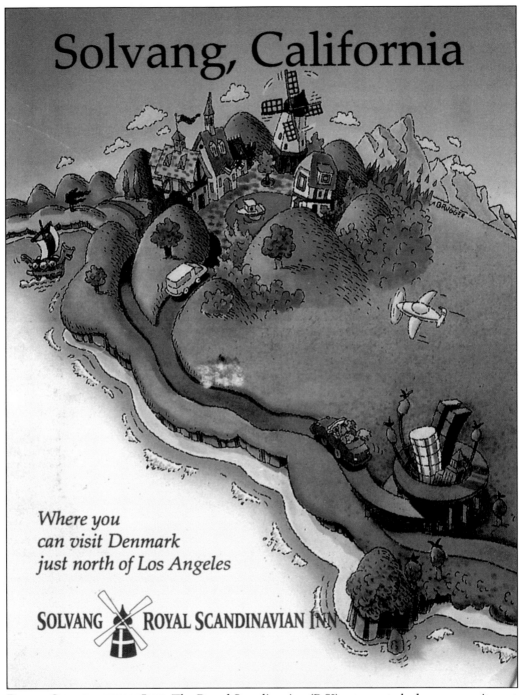

ROYAL SCANDINAVIAN INN. The Royal Scandinavian (RSI) represented a large commitment to the hotel industry in Solvang, a trend that has been embraced in the modern era. The RSI provided possibilities for small conventions and meetings, further increasing interest in longer-term visits.

MARGARET AND PAUL'S RESTAURANT. This home of Danish fare was established in 1941, well before the tourist trend. However, the owners quickly converted to the Danish provincial style and continued serving traditional Danish dishes along with some American favorites.

MARGARET AND PAUL'S SMORGAASBORD. A glance at the menu could cause fear and trepidation for the non-Dane. The unusual combinations of vowels and consonants could be impossible for the native American to interpret, let along pronounce. The safe bet was to order the roast beef sandwich.

The Village
Silversmith
Solvang, Calif

Actual-Pho

THE VILLAGE SILVERSMITH. Authentic Danish food might not appeal to everyone, but real Danish craftsmanship is hard to compete with. This is particularly true of woodwork and metalwork, including welding and forming a variety of woods and metals as evidenced in the ornate building designs throughout Solvang.

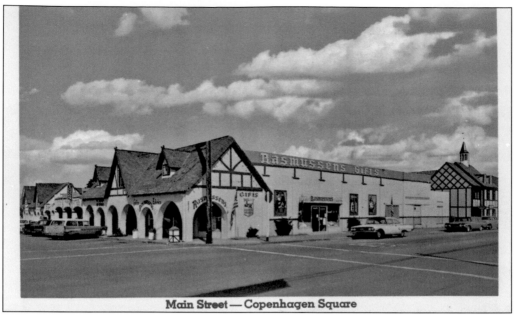

Main Street — Copenhagen Square

RASMUSSEN'S GIFTS. What started out as a grocery and general store evolved into perhaps the most authentic Danish gift store still in operation in Solvang today. The Spanish-style building that houses it provided a design challenge when Solvang converted to Danish architecture.

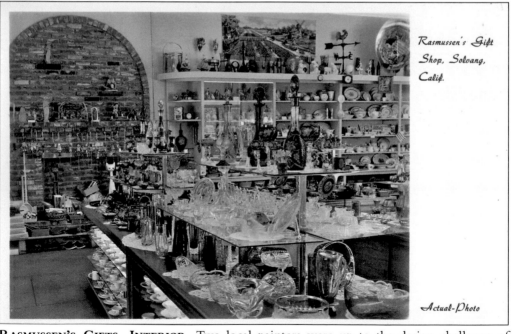

Rasmussen's Gift Shop, Solvang, Calif.

Actual-Photo

RASMUSSEN'S GIFTS, INTERIOR. Two local painters were up to the design challenge of converting the Spanish into Danish. Rather than remodel the building, Delbert Jepsen and artist Paul Kuelgen proposed a painted solution. They spent a week applying the arts and changed the look of this prominent building in Solvang forever without pounding a single nail.

Eight

DANISH DAYS

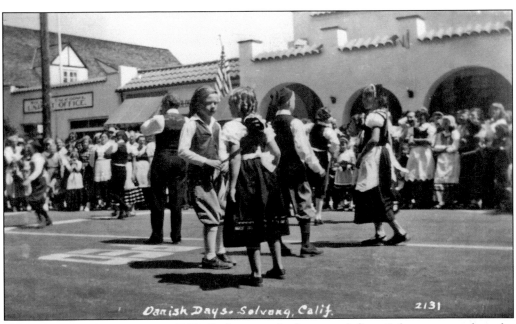

DANISH DAYS FOREVER, C. 1949. Perhaps no single event defines Solvang more than the annual Danish Days celebration. An article in the *Saturday Evening Post* in 1947 put Solvang on the tourism map, but the annual Danish Days celebration kept visitors coming back, and this transformed the town.

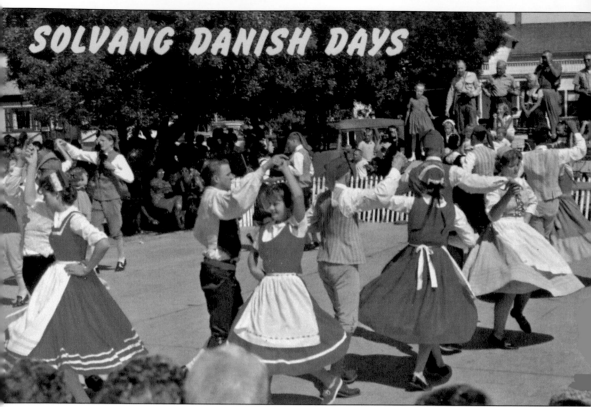

SOLVANG DANISH DAYS

DANISH DAYS CELEBRATION, C. 1960. Is it the costumes, the cultural dances, or the sheer charm of the town and people that appeals to so many visitors? Undoubtedly even the Danes who started it might have a hard time explaining what made the magic of the first Danish Days celebrations. Whatever it was, it brought people to Solvang.

BEFORE DANISH DAYS. Before the publicity that spawned the modern Danish Days, the locals celebrated an annual cultural event by performing traditional Danish dances, songs, and plays. Some of the locals from the surrounding towns probably attended these early events, but for the most part, they were hard to follow because all of the singing and speaking was in Danish.

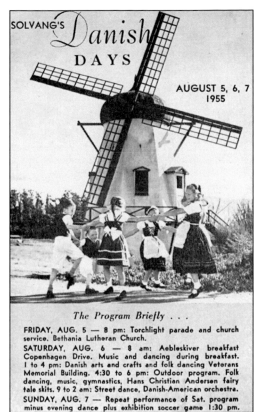

SOLVANG'S *Danish* DAYS

AUGUST 5, 6, 7 1955

The Program Briefly . . .

FRIDAY, AUG. 5 — 8 pm: Torchlight parade and church service. Bethania Lutheran Church.

SATURDAY, AUG. 6 — 8 am: Aebleskiver breakfast Copenhagen Drive. Music and dancing during breakfast. 1 to 4 pm: Danish arts and crafts and folk dancing Veterans Memorial Building. 4:30 to 6 pm: Outdoor program. Folk dancing, music, gymnastics, Hans Christian Andersen fairy tale skits. 9 to 2 am: Street dance, Danish-American orchestra.

SUNDAY, AUG. 7 — Repeat performance of Sat. program minus evening dance plus exhibition soccer game 1:30 pm.

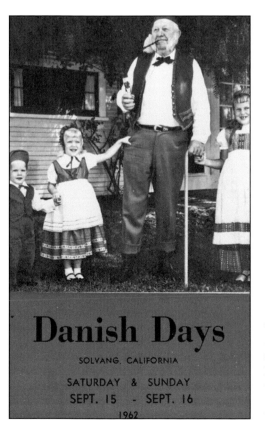

Danish Days

SOLVANG, CALIFORNIA

SATURDAY & SUNDAY
SEPT. 15 - SEPT. 16
1962

THE MODERN DANISH DAYS. The celebration that ensued following the publicity in the *Post* morphed into something much larger than the locals ever anticipated. In fact, the celebration had grown so large by the late 1950s that the organizers decided to take a year off to give themselves and the town a rest.

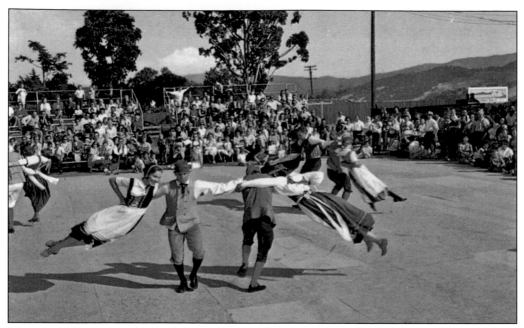

WHIRLING DANCERS. Part of the attraction of Danish Days is the traditional dances carried out in the midst of the several-day celebration. Like the windmills in town, the spinning dancers are a spectacular sight.

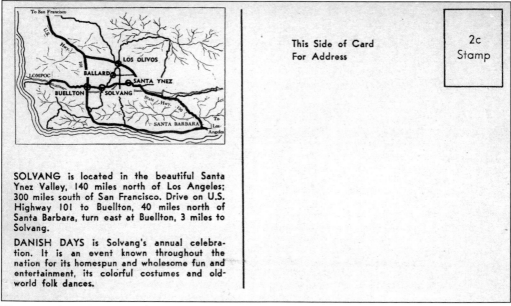

SOLVANG is located in the beautiful Santa Ynez Valley, 140 miles north of Los Angeles; 300 miles south of San Francisco. Drive on U.S. Highway 101 to Buellton, 40 miles north of Santa Barbara, turn east at Buellton, 3 miles to Solvang.

DANISH DAYS is Solvang's annual celebration. It is an event known throughout the nation for its homespun and wholesome fun and entertainment, its colorful costumes and old-world folk dances.

This Side of Card
For Address

2c
Stamp

HOW TO GET HERE. By the 1950s, promotional postcards were used as tools to attract tourists to the festival. Many generations of visitors have since come to enjoy the annual celebration.

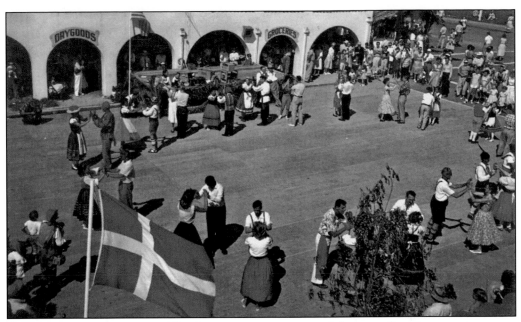

DANCING IN THE STREETS. The dance stage moves around the town from year to year, more recently settling into one of the public parking lots created to accommodate the increasing number of cars that come to visit.

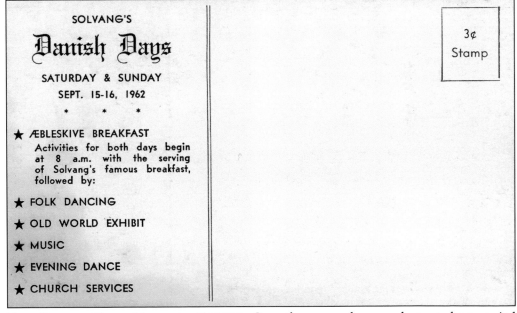

SOLVANG'S

Danish Days

SATURDAY & SUNDAY

SEPT. 15-16, 1962

* * *

★ ÆBLESKIVE BREAKFAST
Activities for both days begin at 8 a.m. with the serving of Solvang's famous breakfast, followed by:

★ FOLK DANCING

★ OLD WORLD EXHIBIT

★ MUSIC

★ EVENING DANCE

★ CHURCH SERVICES

3¢
Stamp

THE DANISH DAYS MENU OF EVENTS. Over the years, the annual events have varied somewhat, but this promotional postcard from 1962 describes the usual events. The only question is, "What is an aebleskive?"

THE AEBLESKIVE BREAKFAST. An aebleskive can simply be described as a sugary, deep-fried dough ball covered in jam. These Danish delicacies are a Danish Days favorite and an ongoing feature of the annual festival.

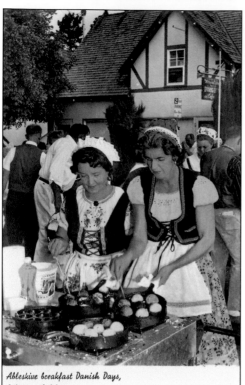

Ableskive breakfast Danish Days,
Soluang, Calif. *Actual Photo*

Danish Days Festival, Soluang, Calif.
Actual Photo

TRADITIONAL COSTUMES. Danes and non-Danes alike don traditional Danish garb to celebrate the occasion. Lederhosen and aprons over bright blue and red dresses with detailed stitching are the required wear for a Danish Days celebration.

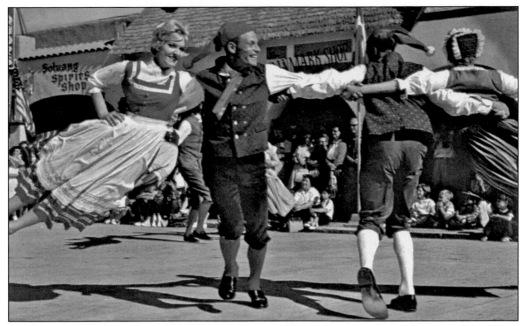

JOINING THE FUN. Even visitors were encouraged to join in the fun and learn the dances or participate in games. Most were content to watch and eat aebleskive or sample the local pastries.

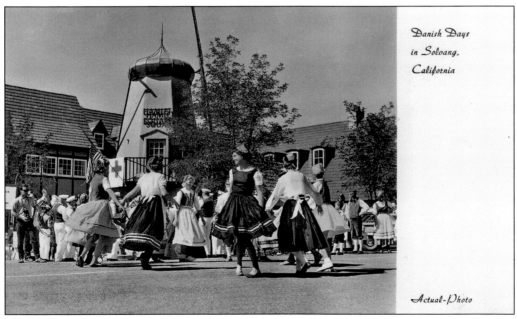

Danish Days
in Solvang,
California

Actual-Photo

MORE DANCING IN THE STREETS. In the modern version of Danish Days, dancing has taken a back seat to what has probably become the biggest event of the weekend celebration: the Danish Days parade.

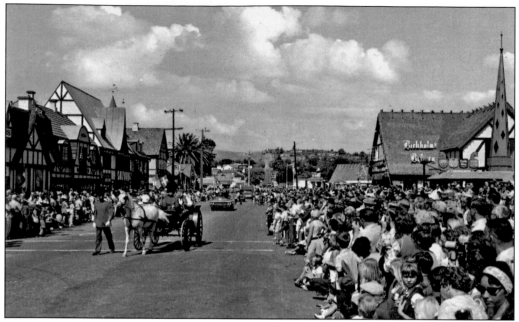

THE PARADE AT ITS PEAK. The Danish Days celebration probably reached its peak in the late 1950s and 1960s, when 10,000 to 15,000 people would stream into town, overwhelming the local populace. This view of the Danish Days parade up Alisal Road attests to the popularity of the event.

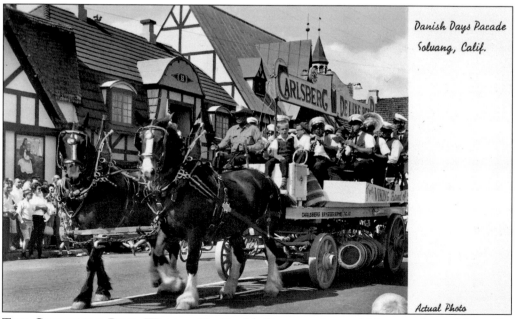

Danish Days Parade
Soluang, Calif.

Actual Photo

THE CARLSBERG BEER WAGON. No Danish Days parade would be complete without the Carlsberg Beer wagon, or for that matter, a Viking ship. Of course there is also a variety of marching bands, classic cars, and homespun floats.

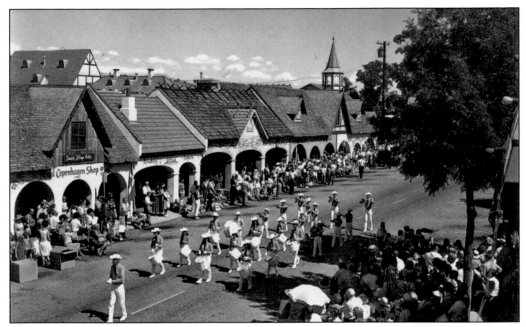

DANISH DAYS TODAY. The Danish Days celebration has survived for over 40 years in Solvang, still attracting droves of visitors and local participants. There are other events, like bicycle rides and racing, that attract large crowds too, but the Danes still rule the day in Solvang.

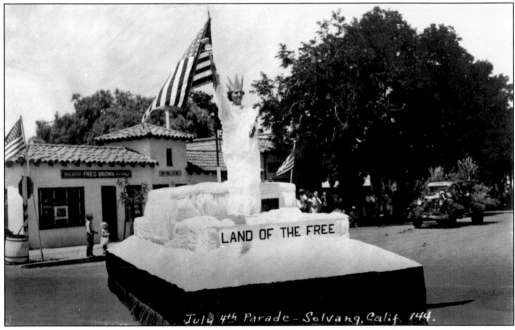

INDEPENDENCE DAY. The annual Fourth of July parade in Solvang is probably as large as the Danish Days parade. It is a unique phenomenon in Denmark, where they share this truly American holiday in their native country as a show of gratitude for U.S. support of their country during the world wars.

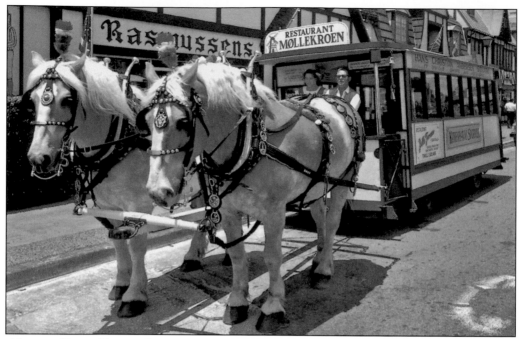

DANISH DAYS EVERY DAY. Every day is a Danish Day in Solvang, where the visitors are surrounded by the interest and excitement of windmills, architecture, and a horse-drawn streetcar harkening back to Denmark. Even native Danes remark about what a wonderful interpretation Solvang represents of their home.

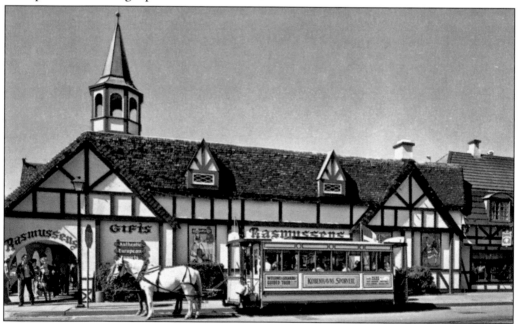

THE WONDER OF SOLVANG. Where else can a cultural town built in the shadow of a Spanish California mission with American pioneer roots reinvent itself into a European wonderland? Perhaps the conversion of the Rasmussens store from a Spanish arcade to a Danish provincial building best illustrates the Solvang of yesterday and the one known and loved today.

Nine

ALISAL GUEST RANCH

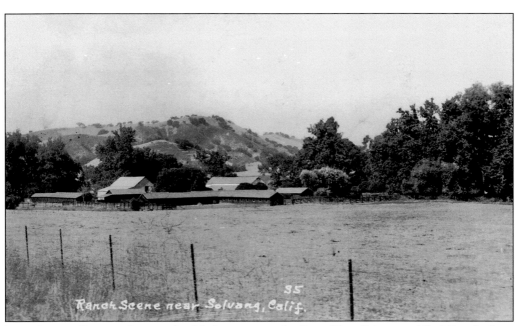

THE ALISAL RANCH. Just south of Solvang across the Santa Ynez River on Alisal Road, there is another style of life that is a reminder of an earlier existence in the Santa Ynez Valley, before the Danes arrived and even for a while after.

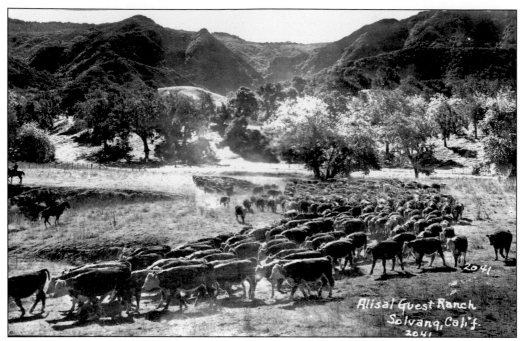

CATTLE RANCHING. Cattle ranching ruled the Santa Ynez Valley of the late 1800s and early 1900s. It is still part of the local economy today. The 10,000-acre Alisal Ranch remains as a testament to those times, although like Solvang, it began catering to the tourist trade following World War II.

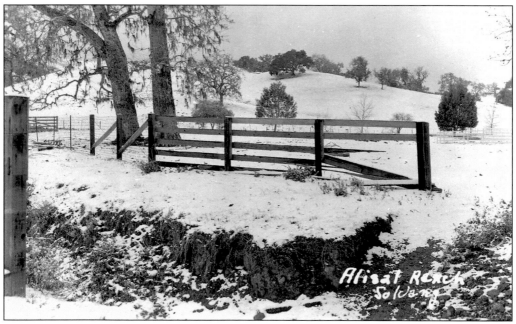

SNOW AT THE ALISAL RANCH. In January 1949, an unusually heavy snowstorm blanketed the Alisal Ranch and all of the Santa Ynez Valley. Several postcards featuring the snow around the valley were created and sold, because it was such an unbelievable sight.

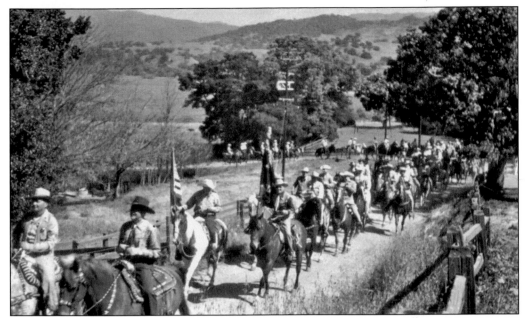

A REAL RANCHING OPERATION. Prior to World War II, the Alisal played host to real cowboys and some wannabes as well. The mainstay of the ranch was an actual cattle operation, but on the annual occasion of the trek of the Rancheros Visitadores, the ranch played host to the hijinks of some well-heeled dudes who mixed with the real local talent.

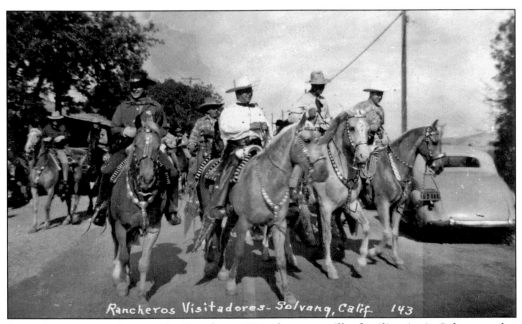

Rancheros Visitadores- Solvang, Calif. 143

RIDE RANCHEROS RIDE. The Rancheros Visitadores are still a familiar site in Solvang today as they head out from the Mission Santa Ines for the annual trek in May. This riding tradition was started by a few locals in 1930 and has grown to hundreds of participants today.

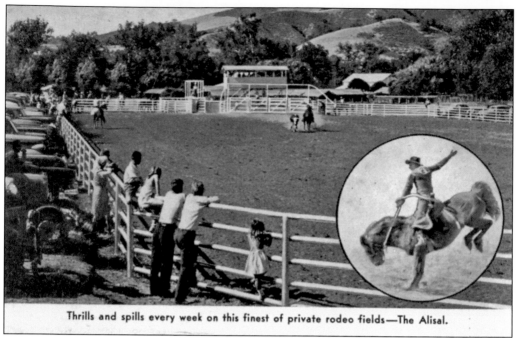

Thrills and spills every week on this finest of private rodeo fields—The Alisal.

THE ALISAL RODEO GROUNDS. Some real bronco busting was done at the Alisal Ranch under the ownership of Charles Perkins. He also introduced a breed that would have a long-term effect on the evolution of horse breeding in the Santa Ynez Valley: the Thoroughbred. One of his Thoroughbreds, named Flying Ebony, even won the 1933 Kentucky Derby.

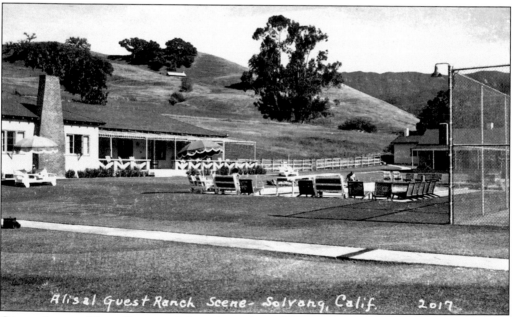

Alisal Guest Ranch Scene- Solvang, Calif. 2017

COME ALONG NOW DUDES. When the Jackson family took over ownership of the Alisal Ranch, it soon saw the opportunity for a guest ranch. Coincidentally, the family began inviting guests in 1946, not long before Solvang debuted as a tourist destination.

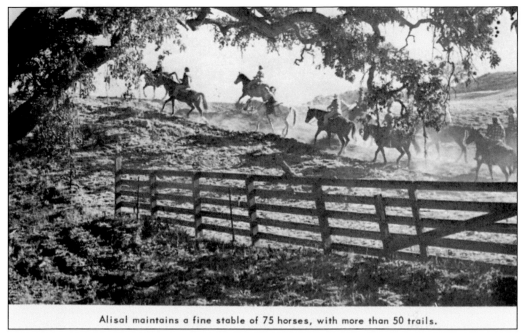

Alisal maintains a fine stable of 75 horses, with more than 50 trails.

RIDING THE TRAILS. Following the war, the United States was in the throes of a rebirth of Western nostalgia celebrated in television shows and movies. This manifested itself further with the advent of the dude ranch. The timing couldn't have been better for the Alisal to emerge as a place to express one's inner cowboy or cowgirl.

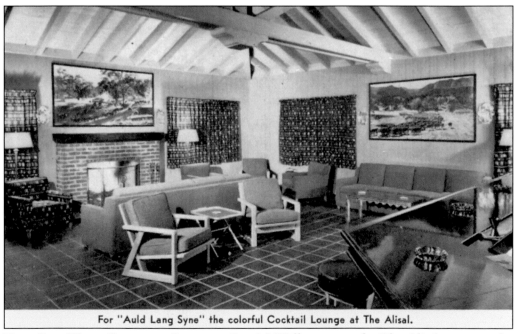

For "Auld Lang Syne" the colorful Cocktail Lounge at The Alisal.

THE OLD WEST COCKTAIL LOUNGE. Rustic? Well, not exactly. The Alisal caters to the upscale dude, with a guest list that has included stars like Gregory Peck, Ava Gardner, Groucho Marx, and Kirk Douglas. Clark Gable even had his wedding to Lady Sylvia Ashley here.

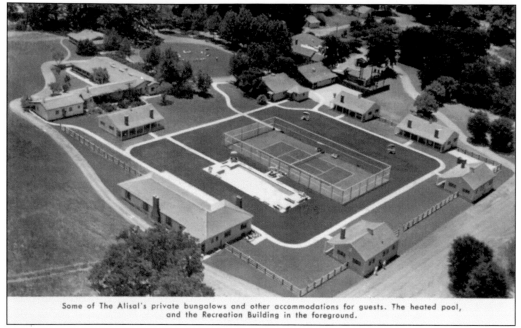

Some of The Alisal's private bungalows and other accommodations for guests. The heated pool, and the Recreation Building in the foreground.

AS SEEN FROM ABOVE, C. 1950. This aerial view shows the guest cottages surrounding the tennis court and pool, the main centers of attraction. The Alisal offers enjoyment for the aspiring cowboy and the sun–seeking vacationer.

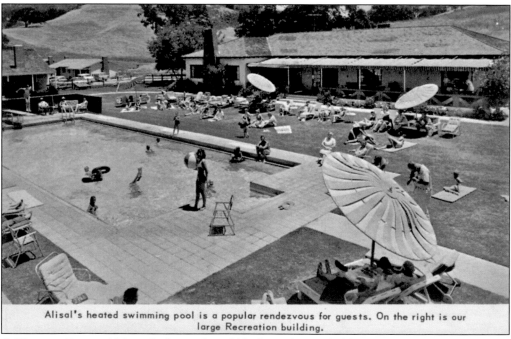

Alisal's heated swimming pool is a popular rendezvous for guests. On the right is our large Recreation building.

A HEATED POOL. Although the pool could be heated, it probably wasn't necessary during the hot summer months in the Santa Ynez Valley. In fact, a cool pool would be quite refreshing following a dusty trail ride at the Alisal Ranch.

Ten

THE SANTA YNEZ VALLEY

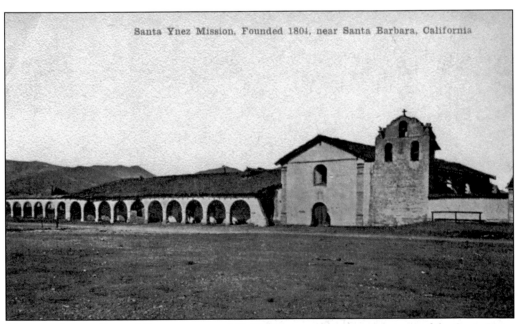

Santa Ynez Mission, Founded 1804, near Santa Barbara, California

MISSION SANTA INES. Like many coastal California communities, the story of the Santa Ynez Valley begins with a mission. The namesake mission in this case was established in 1804, the 19th in the mission chain along El Camino Real.

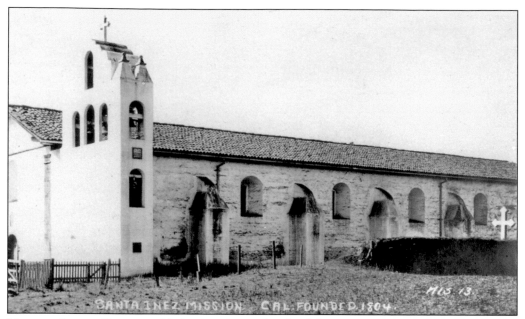

MISSION LANDS DIVIDED. Under Mexican rule of California, the vast lands surrounding the mission were divided into grants and given to individuals or families deemed worthy by the Mexican governors. In the late 1880s, as gold wealth flowed down the coast, many of these vast ranchos were subdivided and sold.

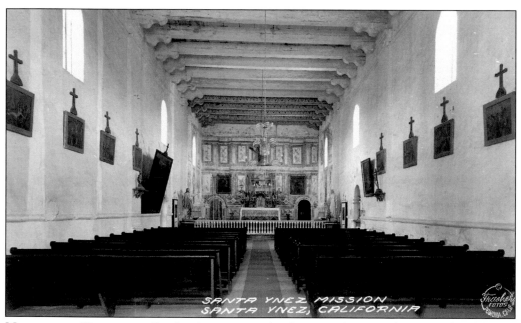

MISSIONS IN DISREPAIR. By the time new settlers began arriving in this part of California, the mission had declined significantly due to neglect and disinterest. Fortunately a renewed interest in the missions as historic structures would lead to the rescue of most of them in the early 1900s.

THE CLOISTER. Mission Santa Ines was not one of the most architecturally significant of the chain, but it was certainly worthy of restoration. In the meantime, hearty pioneers bought up the land around it and began developing it into ranches, farms, and towns.

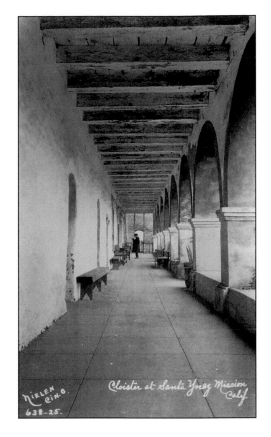

THE MISSION AT REST. During the late 1800s and the early 1900s, there was minimal activity at the mission, but there was plenty going on around it. New towns were springing up as the Santa Ynez Valley found itself becoming a transportation hub on the central coast.

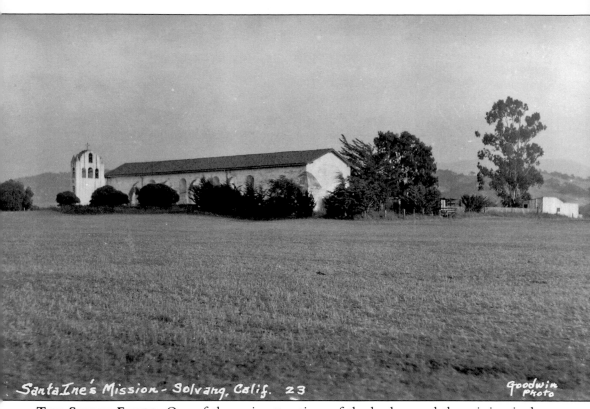

Santa Ines Mission - Solvang, Calif. 23 Goodwin Photo

THE SUNNY FIELDS. One of the main attractions of the land around the mission is that it can provide a vast forage crop for horses, sheep, and cattle. The land along the river also held promise for fertile farming. The valley was capable of producing far more than local transportation methods could deliver.

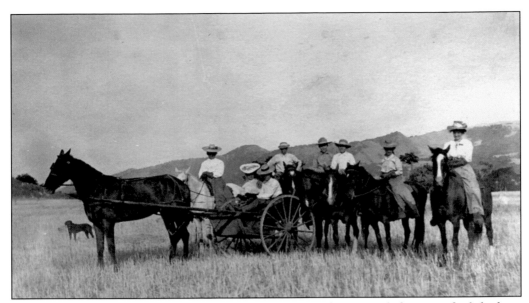

HORSE-POWERED TRANSPORTATION. There was more than enough forage to feed the hay-burning population that drove the vehicles and provided transport. There was even plenty to feed the cattle and the sheep. When the weather cooperated, there was far more than could be used locally.

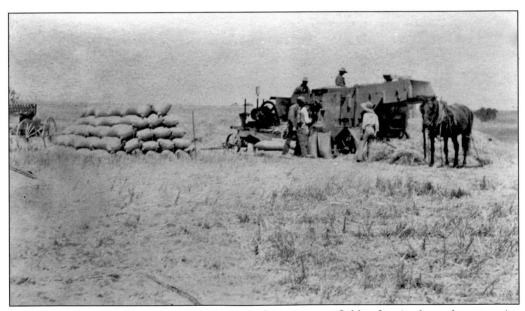

DRY FARMING AND THRESHING. The early farmers grew fields of grain dependent on rain. The crops were often bountiful, but horse-drawn wagons could only deliver the loads short distances. The closest port was at Gaviota, which was a slow day's journey away.

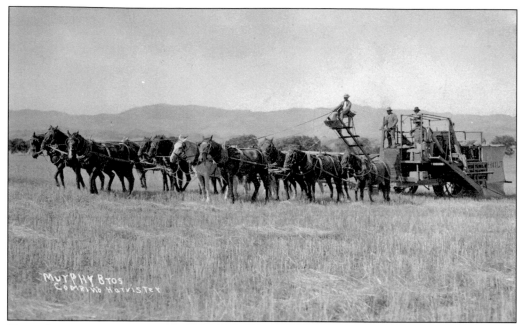

TALK ABOUT HORSEPOWER. As machinery and ingenuity increased, so did the crop size. A solution was needed to move these crops to bigger markets and to move bigger loads at one time.

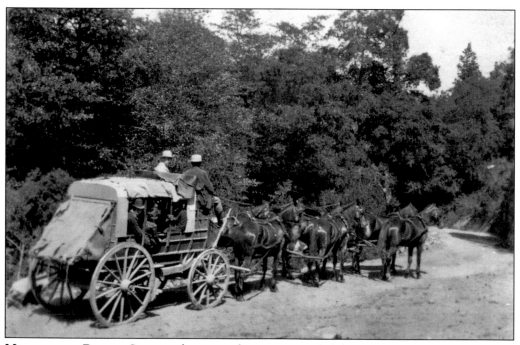

MAKING THE PASSES. Stagecoaches or mud wagons provided the main means of transportation for humans and goods to points further north and south. The valley's first town was established as a stagecoach stop to accommodate the weary travelers arriving over San Marcos Pass.

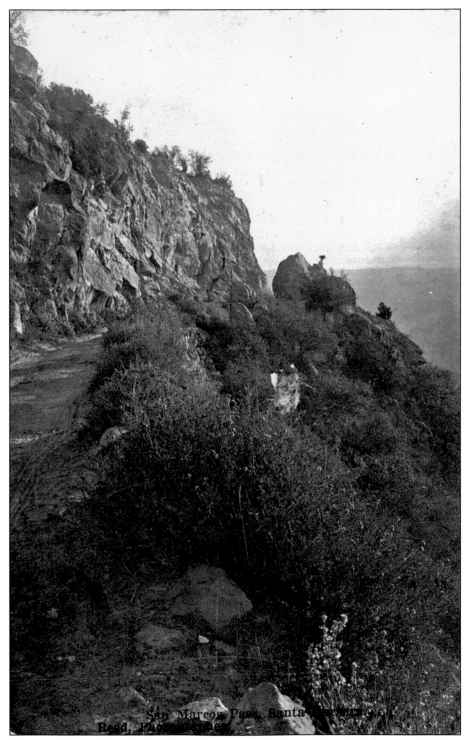

San Marcos Pass, Santa Barbara Co.
Reed, Photographer

SAN MARCOS PASS. The trip from Santa Barbara to the Santa Ynez Valley took a full day, with several stops and changes of horses. Stops were developed at points up, along, and over the pass to accommodate the stages.

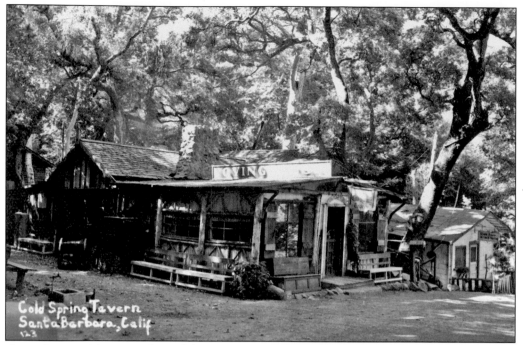

COLD SPRING TAVERN. One of the stage stops still exists today, although a bit off the beaten path of the modern Highway 154. The Cold Spring Tavern on Stagecoach Road serves food to adventurous drivers, much like it once served refreshments to stage passengers.

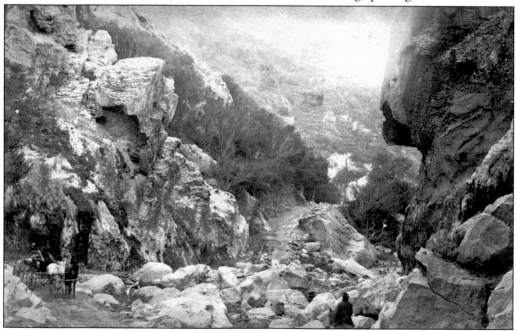

THE GAVIOTA PASS. An alternative to the climb over the Santa Ynez Mountains existed along the coastline north of Santa Barbara. The trek through the Gaviota Pass only required a four-horse team rather than six, but the coastal road could be subject to the whims of the oceans or rock slides at the pass.

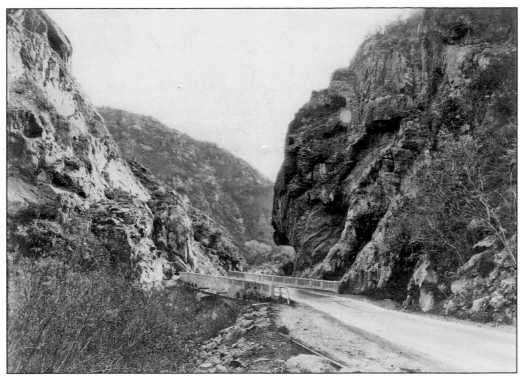

GAVIOTA PASS BRIDGE. The Gaviota Pass has always possessed a mystical aspect because of the Native American rock face guarding the gorge. Today drivers pass by so fast they hardly notice it, but in the early days of the automobile, drivers traveling at around 25 miles per hour could certainly appreciate it.

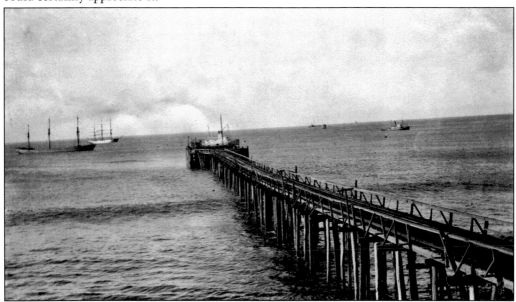

THE GAVIOTA WHARF. The Gaviota Wharf was the closest port to the Santa Ynez Valley. With only horse-powered vehicles as an alternative in the 1800s, most of the surplus crop was hauled here in wagons.

THE ARRIVAL OF IRON HORSES. In the late 1870s, a promising development occurred that had the potential to solve some of the transportation problems for the Santa Ynez Valley. A narrow-gauge railroad was being constructed from Port Harford in Avila Beach into San Luis Obispo and down the coast.

THE TRAIN TO LOS ALAMOS. The train arrived in the town of Los Alamos in 1882, just 15 miles north of the Santa Ynez Valley. There was rampant speculation that the train would continue all the way to Santa Barbara. Land speculators began buying up large parcels in the Santa Ynez Valley in anticipation of the train's arrival.

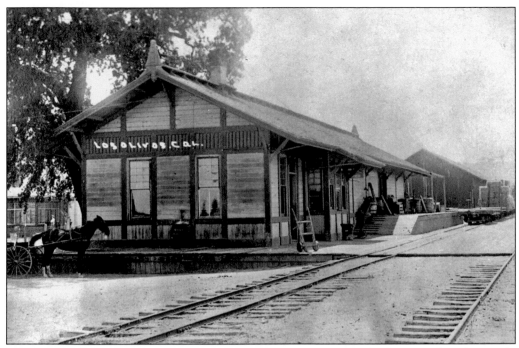

THE TRAIN TO LOS OLIVOS. It took five years, but the train finally arrived at the newly created town of Los Olivos. The town was a creation of the railroad, intended to take advantage of land speculation by its very creation. It would serve as the southern terminus of the railroad until 1934.

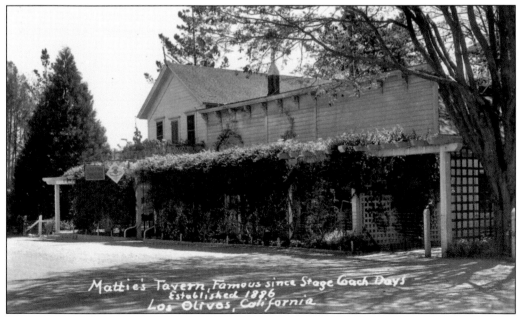

MATTEI'S TAVERN. A Swiss immigrant name Felix Mattei secured property across the street from the proposed Los Olivos depot the year before the train arrived and built a hotel. The land speculators also built a grand hotel to accommodate the customers waiting to transfer from stagecoach to railroad.

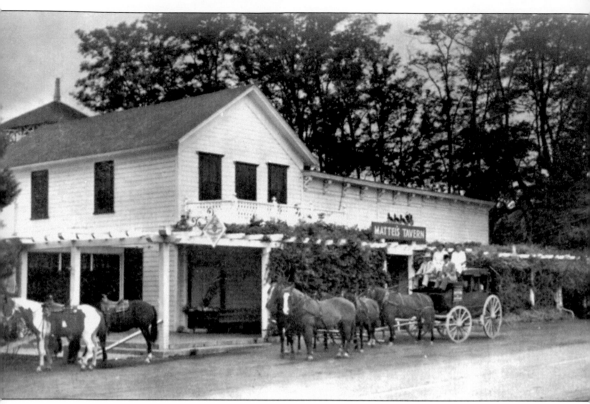

MATTEI SECURES THE STAGE. Mattei also managed to tie up the stagecoach business that would transport passengers to and from Santa Barbara when they arrived in Los Olivos. This provided him with a steady stream of business, as the passengers needed a one-night stay before departing.

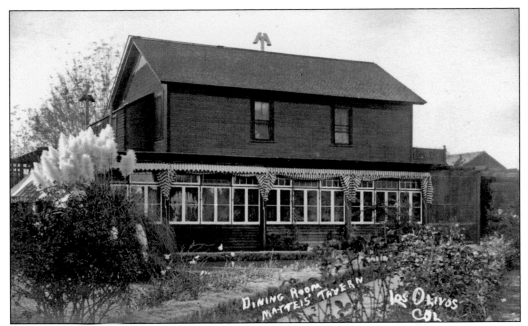

THE TAVERN GROWS. The land speculators' hotel burned down less than two years after it was built, leaving Mattei with a bustling hotel business. He expanded his tavern with bungalows and dining to accommodate the additional guests.

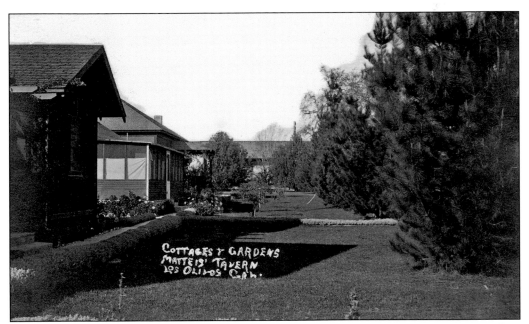

THE END OF THE LINE. When the Southern Pacific Railroad closed the gap in its line along the coast in 1901, the stagecoaches and narrow-gauge railway became obsolete for most passenger transportation. Mattei was faced with a temporary downturn in business that would soon be revived with the arrival of the automobile.

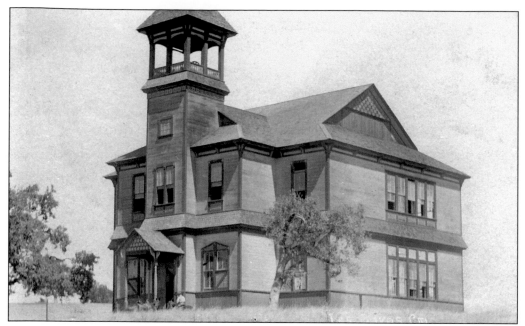

THE LOS OLIVOS SCHOOL. The Los Olivos School was constructed in 1890 to accommodate the growing population of students. Prior to that, children attended classes in the nearby town of Ballard.

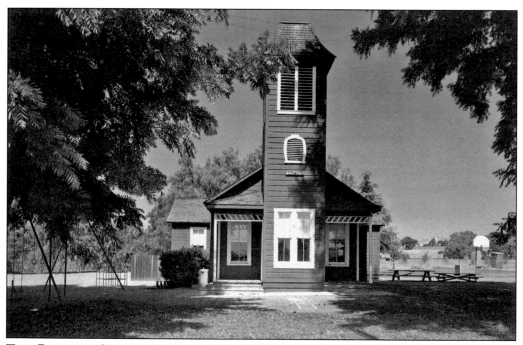

THE BALLARD SCHOOL LEGACY. Ballard School has the distinction of being the longest continuously operating school building in the state of California. Classes have been held in the red school building since it was constructed in 1883.

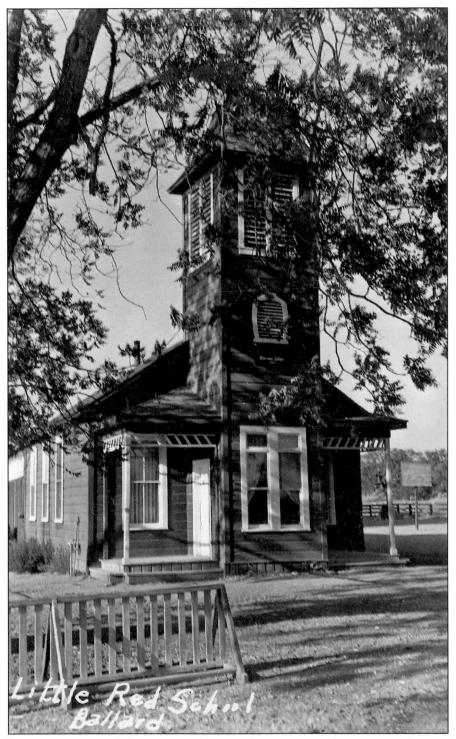

Little Red School
Ballard

THE BALLARD SCHOOL. The town of Ballard is the oldest town in the Santa Ynez Valley. It was established as the first stagecoach stop in the area. The Ballard schoolhouse was completed in 1883.

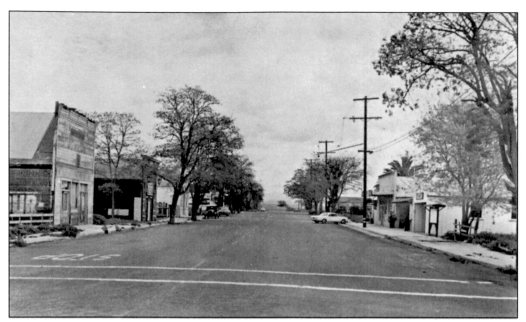

THE TOWN OF SANTA YNEZ. The town of Santa Ynez was originally going to be named Sagunto. That name was given to the main street instead, and the town was named after the mission. This image, although taken in the early 1970s, still reveals the early Western heritage of Santa Ynez.

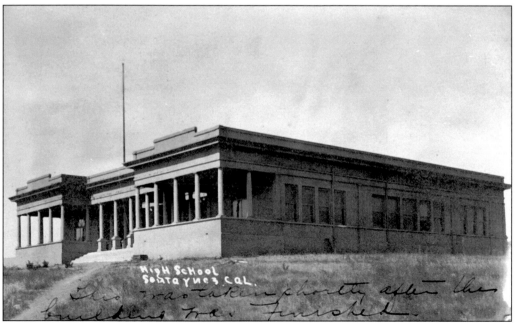

SANTA YNEZ HIGH SCHOOL. The first high school was built on a hill at the edge of the town of Santa Ynez. Prior to that, students met in the Santa Ynez Grammar School building until it burned down. This building was condemned in 1934, and a new school was built at the present site on Mission Drive and Refugio Road.

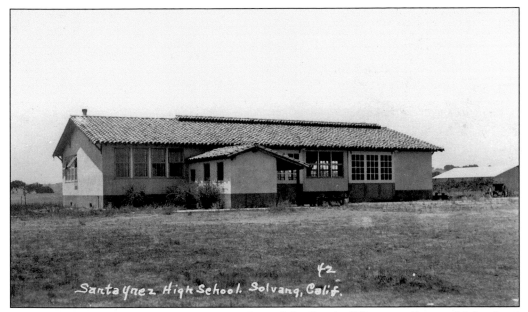

SANTA YNEZ HIGH SCHOOL BUILDING. One of the first buildings on the new high school campus housed agricultural shop classes. It was built even before actual classrooms. Classes were held in canvas tents for the first year.

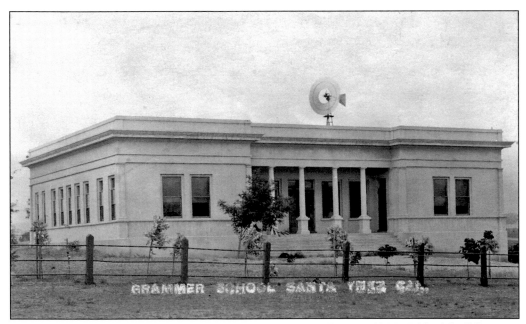

AFTER THE SANTA YNEZ GRAMMAR SCHOOL BURNED DOWN, 1908. A block building was constructed to replace the school. It provided a solid foundation for education in Santa Ynez for many years to come.

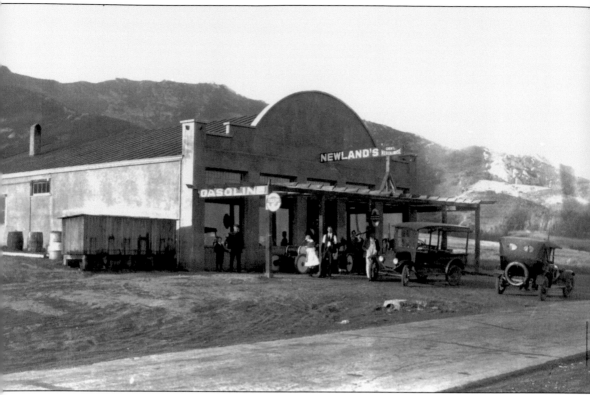

ARRIVAL OF THE HORSELESS CARRIAGE. As the early 1900s dawned, horseless carriages began arriving along the coast of California. Small towns sprang up to provide services to these automobiles. This station at Gaviota Beach was one of the earliest along the coast route in northern Santa Barbara County.

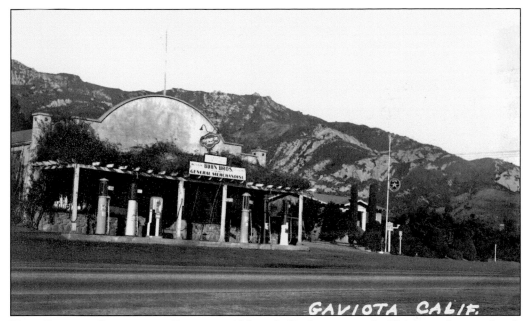

THE GAVIOTA STORE AND STATION. Although Gaviota was and still is sparsely populated, the station owners added general merchandise for the local ranchers and oncoming automobile travelers.

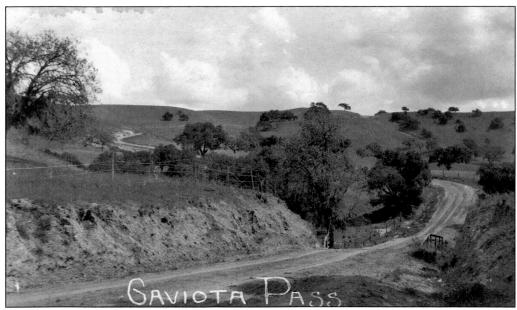

THE GAVIOTA ROAD. This stretch of road is representative of what most of the early Coast Highway looked like until at least 1922. Shale was used to surface the road that carried carriages, wagons, and automobiles into and out of the Santa Ynez Valley.

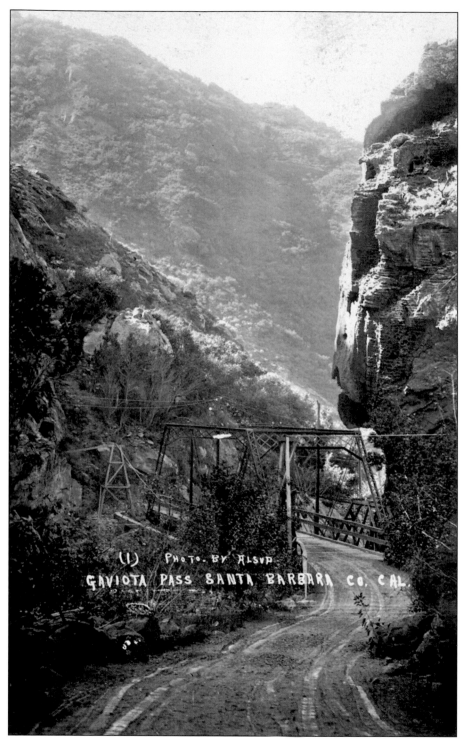

GAVIOTA BRIDGE. A steel truss bridge was installed at the Gaviota Pass to improve the creek crossing for automobiles and wagons. It became impassable when clogged by a herd of cattle or sheep being driven from the Santa Ynez Valley to the Gaviota Wharf.

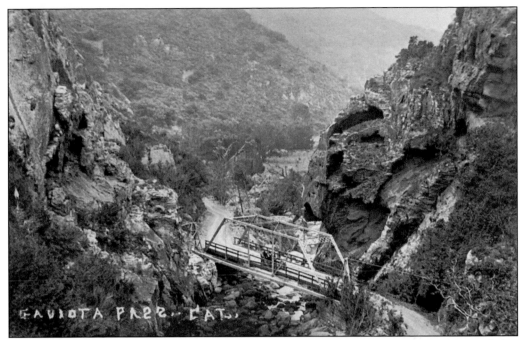

THE EARLIEST AUTOMOBILES. Driving was certainly an adventure in early automobiles. Sharp shale was hard on balloon tires, steep grades caused frequent overheating, and gasoline and oil could be scarce. These new oil burners demanded new kinds of service, and the small towns complied as service stations and gas pumps sprang up every 15 miles or less.

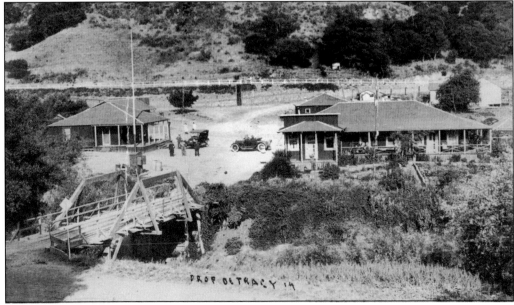

THE TOWN OF LAS CRUCES. The town of Las Cruces was originally a stagecoach stop located at a *Y* intersection where the Santa Ynez Valley and Lompoc Valley converged on the way to the Gaviota Wharf. Automobiles soon replaced cowboys as the main customers in the small town.

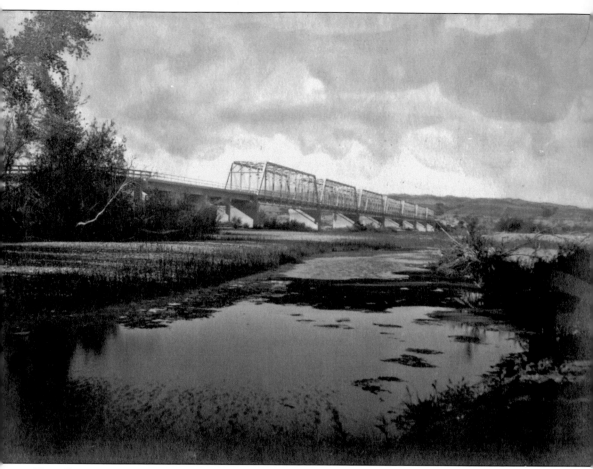

THE BRIDGE TO BUELLTON. Prior to 1918, the Coast Highway, later to become Highway 101, ran around the Nojoqui grade past the Alisal Ranch and through Solvang to Los Olivos. In 1918, a new bridge was constructed through the Buell Ranch and the road was rerouted, creating a new town named Buellton.

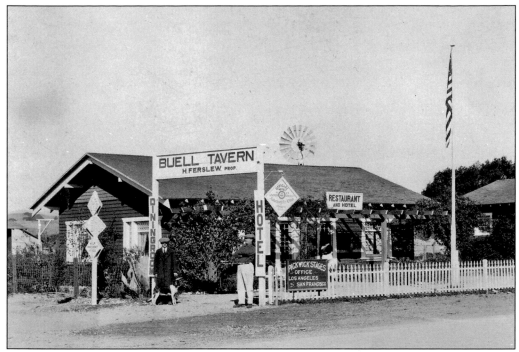

THE BUELL TAVERN. One of the first businesses in the new town was the Buell Tavern, owned by Harold Ferslew. Across the street Knud Moeller opened a service station. These early businesses provided the first foundations of a soon–thriving service town.

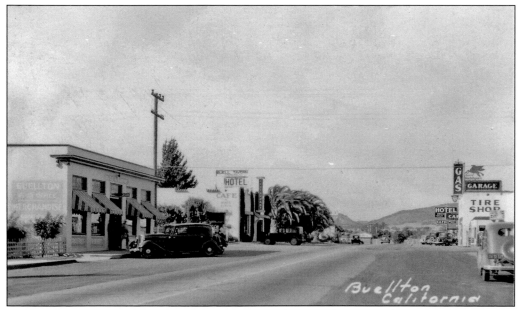

NORTH ON HIGHWAY 101. This view looking north on Highway 101 through Buellton shows the emerging service town in the 1920s. By now, the main attraction was a well-known diner serving its famous split pea soup named Andersen's.

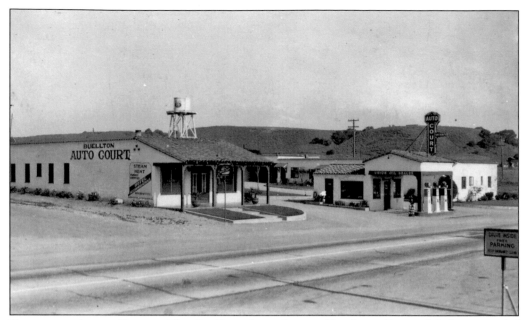

BUELLTON AUTO COURT. The Buellton Auto Court offered gasoline and lodging, as did many of the small auto courts and motor courts along the highway. As the reliability of cars increased, so did the travelers along the coast.

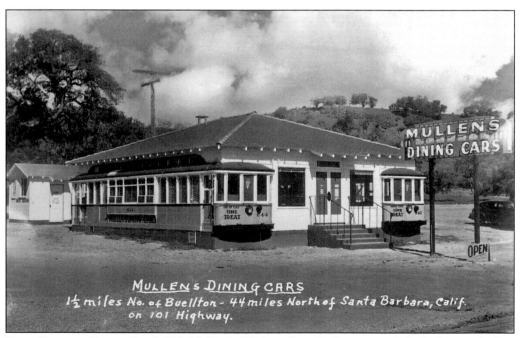

THE DINING CARS CAFÉ. Ed Mullen's Dining Cars Café was a relatively late arrival to Buellton, not appearing until 1946. Despite the novelty, the restaurant had trouble competing with the widely known pea soup eatery in town. The final meals were served there in 1958, although the cars remained for many more years.

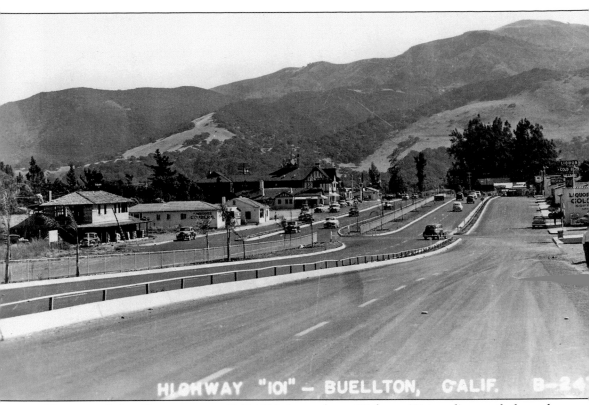

HIGHWAY "101" — BUELLTON, CALIF. B-24

HIGHWAY 101 IN BUELLTON, C. 1949. This image shows Highway 101 traveling south through Buellton shortly after the highway was widened to eight lanes. This highway widening project significantly changed the face of Buellton, as many buildings had to be moved or demolished. A spate of new motel and service station construction along the highway ensued as well.

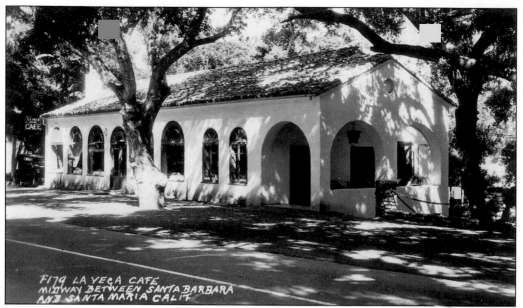

THE LA VEGA CAFÉ, C. 1940. The La Vega Café held its grand opening on October 29, 1929, the day the stock market crashed in New York. All of the local news coverage was about this fine new café, with barely a mention of the catastrophe on Wall Street.

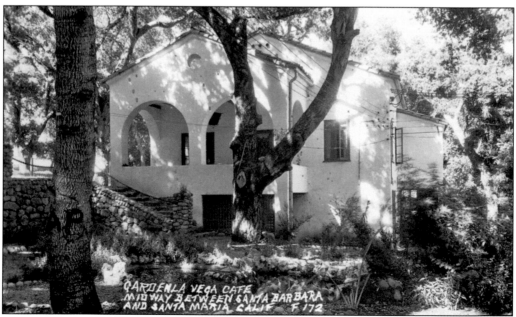

LA VEGA ON 101, C. 1940. La Vega Park and the café were tucked into a small nook along Highway 101 just about a mile south of Buellton. It was a quaint destination frequented by locals and people traveling the highway.

114

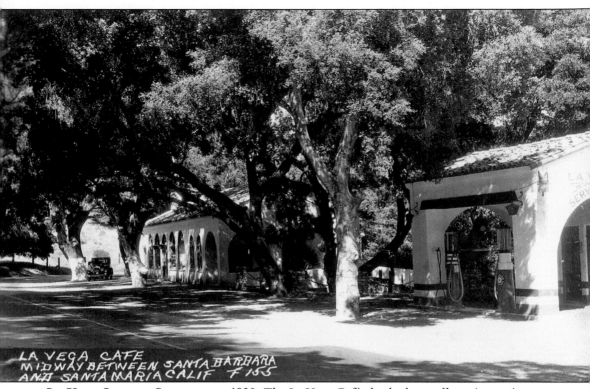

LA VEGA SERVICE STATION, C. 1930. The La Vega Café also had a small service station next door, as seen to the right of this photo postcard. The oak-shaded setting was an ideal stopping place on a hot summer day in the Santa Ynez Valley.

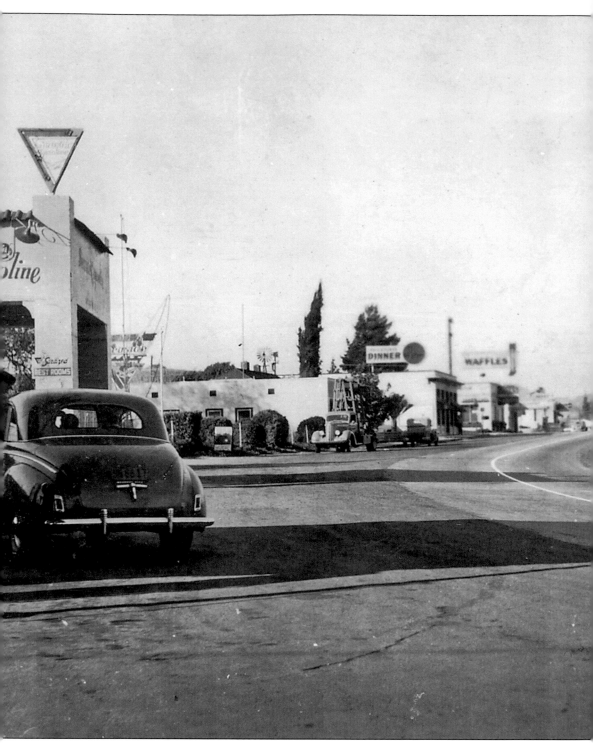

BUELLTON, C. 1940. Although Solvang has emerged in the modern era as the tourist destination in the Santa Ynez Valley, Buellton was once the better-known spot. This was primarily due to the widespread fame of Andersen's pea soup. For those who remember the glory days of the

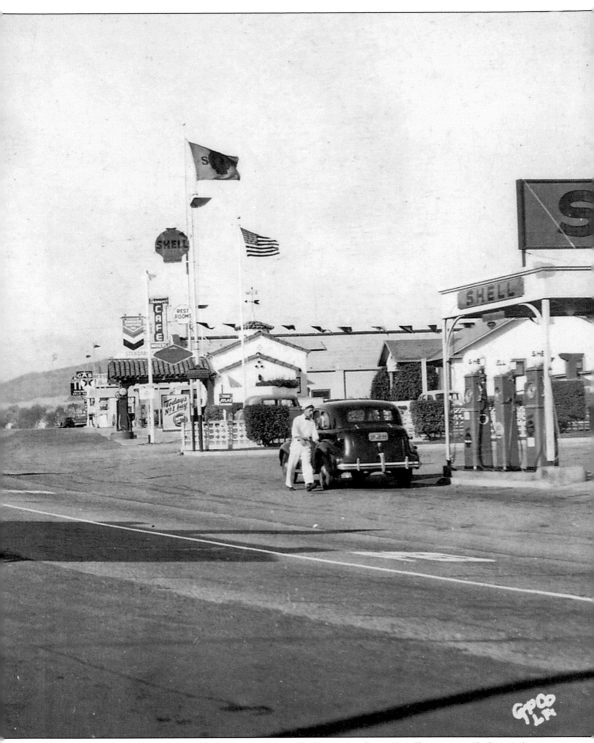

service station, this view of Highway 101 well illustrates how Buellton earned the nickname "Service Town, U.S.A."

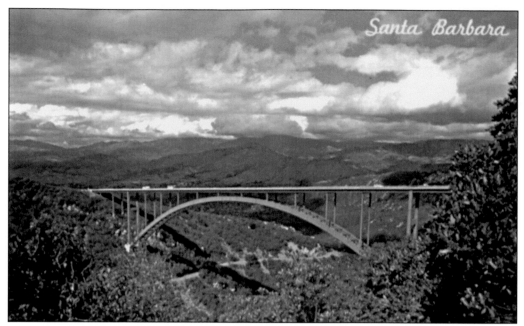

COLD SPRING BRIDGE. The Cold Spring Bridge turned the winding San Marcos Pass into a much straighter shot along Highway 154 into the Santa Ynez Valley. This span took traffic off of the old stagecoach road and took its name from a former stagecoach stop.

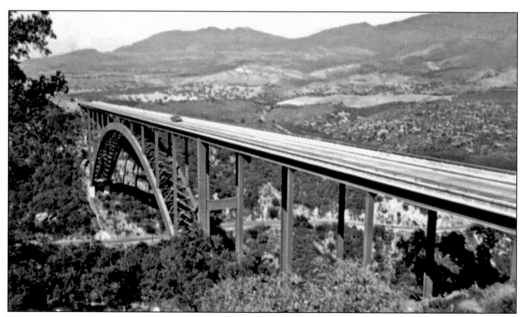

THE COLD SPRING ARCH. Few motorists get to appreciate this view that is unseen while crossing the bridge from above. It requires a drive down below on the old stagecoach road to appreciate the engineering that went into the design of this decorative span.

118

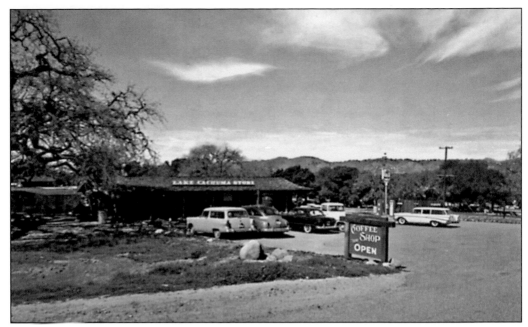

CACHUMA LAKE RECREATION. Also along Highway 154, Cachuma Lake affords a waterfront view. Many people enjoy year-round recreational boating and fishing on this man-made reservoir.

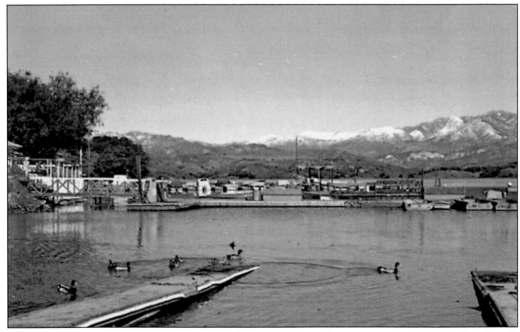

THE DOCKS AT CACHUMA. Visitors can bring their own boat or rent one to try their hands at trout or bass fishing. At one time, the docks even featured their own gas pumps, as seen in this postcard.

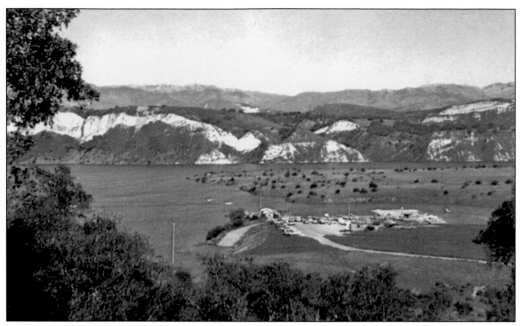

SURROUNDING THE LAKE. Getting out on the lake affords a beautiful view of the surrounding valley and mountains. The north side of the lake is uninhabited and in its natural state, which makes it especially interesting to visit on a cruise around the body of water.

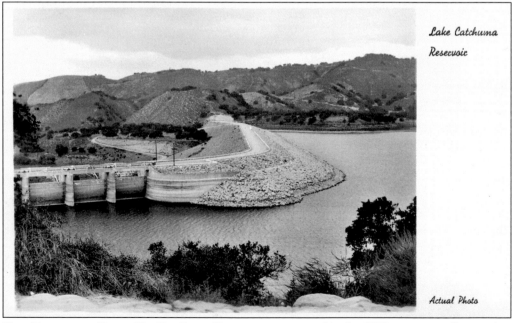

Lake Catchuma Reservoir

Actual Photo

THE BRADBURY DAM. The Bradbury Dam was constructed in the 1950s, temporarily stopping the Santa Ynez River and flooding the valley behind it to create this man-made reservoir. The lake provides water to Santa Barbara and is used to manage the flow of water into the Santa Ynez Valley.

120

American Legion Bldg. Solvang, Calif.

THE VETERAN'S MEMORIAL BUILDING. Constructed in the 1930s as a tribute to veterans of war, this building still serves as a civic center in Solvang today, hosting many events. Located across from the mission, its architecture is decidedly not Danish but rather Mission style.

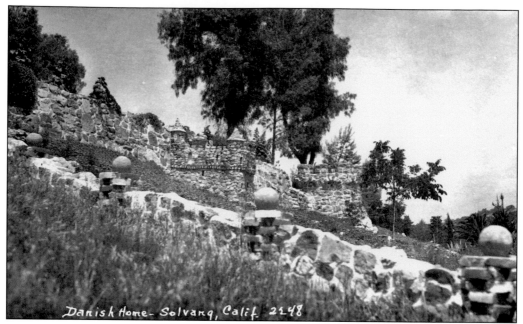

ROCK SORENSEN'S ROCK PALACE. Soren "Rock" Sorensen was a local mason who gained his nickname from his trade. Around his own home, he constructed an elaborate rock fairyland. These interesting structures were celebrated in postcard views around the 1950s.

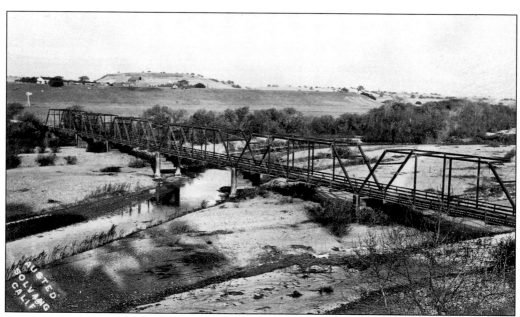

THE ALISAL RIVER BRIDGE. This bridge crosses the Santa Ynez River at Alisal Road, leading from the Alisal Ranch into the town of Solvang. The low-lying bridge was prone to flooding during heavy rains and was eventually replaced by a new bridge further above the waterline.

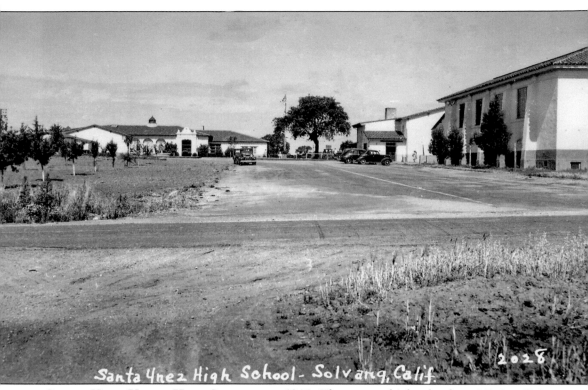

Santa Ynez High School - Solvang, Calif.

2028

SANTA YNEZ UNION HIGH SCHOOL, C. 1945. The present high school on Mission Drive and Refugio Road was constructed in 1935 after the previous building in Santa Ynez was condemned. The classrooms were not completed in time for the new school year in 1935, so the first classes were held in canvas tents.

Joshua Trees in Solvang? This postcard was either a misprint or the photographer's joke. Although the summers can be quite hot in the Santa Ynez Valley, it's unlikely that this view will be found anywhere in Solvang.

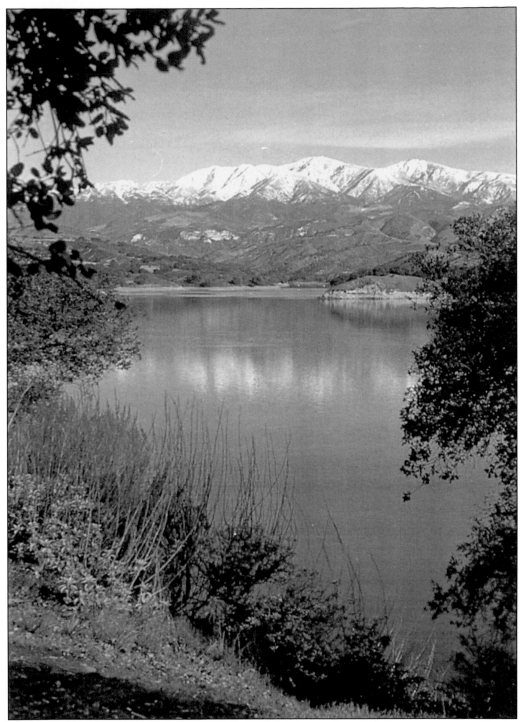

FIGUEROA MOUNTAIN SNOW. Although it is quite rare for the valley floor to see snowfall, the higher elevations around Figueroa Mountain to the north often get a light dusting. Although short-lived, it sometimes lasts long enough for the locals to build a few snowmen and do some sledding.

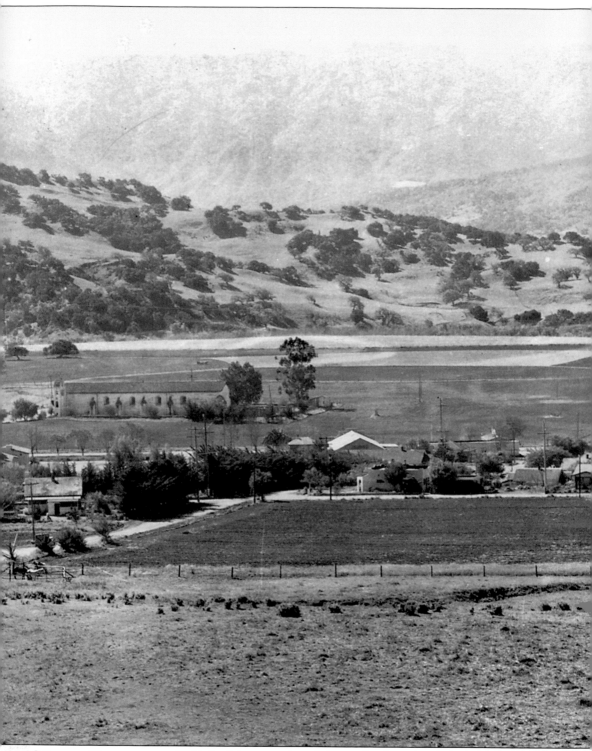

SOLVANG OVERVIEW, C. 1944. In this town view, Solvang slumbers shortly before the end of World War II, completely unaware of the tourism invasion that will ensue before the end of the

decade. This view looking south at the Santa Ynez Mountains is idyllic even today, despite the introduction of Danish architecture that has so significantly changed the face of this land.

DISCOVER THOUSANDS OF LOCAL HISTORY BOOKS
FEATURING MILLIONS OF VINTAGE IMAGES

Arcadia Publishing, the leading local history publisher in the United States, is committed to making history accessible and meaningful through publishing books that celebrate and preserve the heritage of America's people and places.

Find more books like this at
www.arcadiapublishing.com

Search for your hometown history, your old stomping grounds, and even your favorite sports team.

Consistent with our mission to preserve history on a local level, this book was printed in South Carolina on American-made paper and manufactured entirely in the United States. Products carrying the accredited Forest Stewardship Council (FSC) label are printed on 100 percent FSC-certified paper.

MADE IN THE USA